THE BEST OF PRINTMAKING

AN INTERNATIONAL COLLECTION

First published in the United States of America by:
Quarry Books, an imprint of
Rockport Publishers, Inc.
33 Commercial Street
Gloucester, Massachusetts 01930-5089
Telephone: (508) 282-9590
Fax: (508) 283-2742

Distributed to the book trade and art trade
in the United States by:
North Light, an imprint of
F & W Publications
1507 Dana Avenue
Cincinnati, Ohio 45207
Telephone: (800) 289-0963

Other Distribution by:
Rockport Publishers, Inc.
Gloucester, Massachusetts 01930-5089

ISBN 1-56496-371-3

10 9 8 7 6 5 4 3 2 1

Designer: Sawyer Design Associates, Inc.,
Diane Sawyer and Amy Weiss

Cover Image: Detail from *Anaktos*, by Elspeth Lamb (page 35)
Back Cover Images: (clockwise from top) see pages 12, 83, 47, 79

Manufactured in Hong Kong.

THE BEST OF
PRINTMAKING

AN INTERNATIONAL COLLECTION

selected by

Lynne Allen and Phyllis McGibbon

introduction by

Ruth Weisberg

Quarry Books
Gloucester, Massachusetts

PREFACE

In late November of 1996, we spent two days sitting in a darkened motel conference room while 2700+ images were flashed before our eyes. These slides and transparencies had been gathered from artists and print studios around the world in response to an open call for submissions. The entries reflected a myriad of possibilities, utilizing every conceivable printmaking technique and a variety of visual formats. Although this book was not intended to function as a comprehensive survey of the field, the entries nonetheless reflected a wide cross section of contemporary print approaches.

With each blink of the slide projector we were forced to refocus our visual and conceptual parameters as we considered the way each print functioned within its own apparent technical, aesthetic, and geographic/cultural context.

No doubt we responded to some work more readily than others, but we felt it important to include a broad range of approaches to this rapidly changing, yet historically grounded medium. It is never easy to balance the "how to" of printmaking with the "why", yet beyond the immediate visual impact of each work, we were drawn to prints that merged technical processes with conceptual depth and personal conviction. Given the high level of professionalism throughout the entries, our selection process was at once grueling and exhilarating. We lamented having to dismiss extraordinary works that simply didn't photograph well enough to be included in this book. Nonetheless, there were many pleasurable revelations, particularly as we noted how certain visual sensibilities and technical methods have traveled between artists, across many national and cultural boundaries.

Clearly there are remarkable prints emerging from many parts of this world. Although one book can provide only a brief glimpse of this highly expansive medium, it is a pleasure to help make these prints visible to a wider audience. We hope that this is the first of many publications that document the exceptional work currently being produced within the field of contemporary prints.

Lynne Allen
Phyllis McGibbon

4

INTRODUCTION

This beautifully realized book devoted to contemporary printmaking represents a new form for the circulation of print images. I use the word "new" advisedly, as from the very beginning of the printing of wood block and metal plates in the early fifteenth century, books played a crucial role in the dissemination of images. Even into the twentieth century, books and prints have continued to have an intertwined history. Currently, artists interface with their audiences in a myriad of ways from exhibitions to catalogs and from Internet access to portfolio exchanges. What makes this initiative new and different? Both museum exhibitions and national and international print exhibitions are usually accompanied by catalogs. What differentiates this book from other publications is that it is not tied to a specific exhibition and its distribution is international. Also, the method of soliciting entries, the ambition and scale of the project, and the sense of a "virtual" exhibition create a unique situation.

Two very prominent and respected artists/printmakers, Lynne Allen and Phyllis McGibbon, selected 250 entries out of approximately 2,700 submissions. The entries were all juried from slides or transparencies that were solicited via an international call for participation. The numbers are impressive given that this is the first publication of its kind.

While this is not a systematic survey of the field, certain observations can be made about the state of printmaking today. Writing from an American perspective, one can see some measure of the cumulative force of a half-century of renewed interest and activity in printmaking. In the immediate post World War II period, university art departments and art schools flourished partly on account of the GI Bill which brought so many mature and goal-oriented veterans into higher education. In the 50s and 60s, expanding enrollments also meant funds for presses and workshops. The 1960 founding of the Tamarind Lithography Workshop in Los Angeles, California, which was designed to revive the art of lithography, marks the beginning of foundation support for the arts.

There have also been forces at work in the print world that heightened its cosmopolitan and internationalist bent. Printmakers travel widely, work in each other's shops, and exchange prints and technical information. Long-term expatriate experiments such as S. W. Hayter's Atelier 17 in Paris helped create an international printmaking community. There were also many international print exhibitions that encouraged exchange and cross-fertilized influences. These competitions and their system of validation and recognition also allowed printmakers to live and work anywhere within reach of a post office.

The rise of print workshops that published editions in the 60s, and especially the 70s, had a profound effect on how artists defined themselves in relation to prints. With the assistance of highly trained technicians, many more artists had access to print techniques, editioning, and distribution. For an extended period there has been a distinction between the university- or art school–trained printmaker doing their own printing and distribution and painter/sculptor types who typically came to printmaking somewhat later in life and were dependent on the workshop/publishers for technical assistance and distribution. Somewhat separate support systems arose around each set of artists which included galleries, patrons, and publications. However, the resources at the disposal of the printshop/publishers were almost always superior. Recently, there has been some fruitful experimentation in intermingling the two groups of artists and in creating new ways of reaching the public. For example, the Los Angeles Printmaking Society Biennial National Exhibition in 1995, and 1997, both held at the Laband Art Gallery, Loyola Marymount University in Los Angeles, included artists from workshop settings as diverse as Self-Help Graphics, a primarily Latino artists' cooperative in Los Angeles, and Gemini Gel, which has tended to publish only blue-chip New York–and Los Angeles–based artists. What these exhibitions

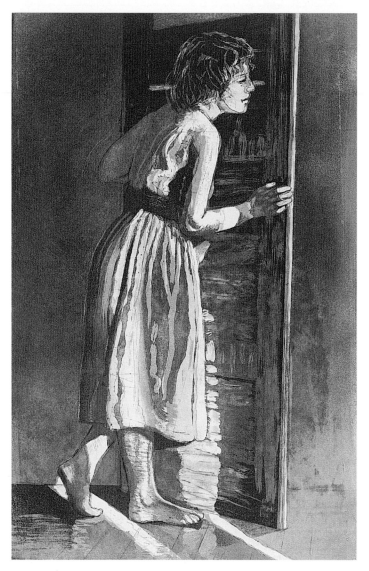

RUTH WEISBERG

Threshold

18" × 12" (46 cm × 31 cm)
Intaglio

demonstrated was that the distinction between types of artists was not based on quality, but rather that it involved validation by different institutions and hierarchies. Print history again and again proves that quality, talent, and inspiration are well distributed and not the privilege of a location, genre, or group.

While the national and international competitions have had their ups and downs, there has been dramatic growth of national and regional printmaking groups. Southern Graphics Council, in particular, has gone from a regionally-based group to a large national conference of artists interested in the print in all its manifestations.

This book gives a lively sense of the current definition of printmaking.

In recent years, printmaking parameters have been expanded to include electronic and digital technologies, new media, and installation strategies. The jurors were quite open to these innovations, although they required that computer technology be used as a mediating process rather than an output. Not only do we see printmaking on the edge, but we also see the renewed interest in traditional techniques such as mezzotint, chine collé, and wood engraving.

In general, Allen and McGibbon tried to choose the highlights of many tendencies and sensibilities. One is struck by the rich diversity of ideas and attitudes represented here. What has been left aside is technique for its own sake in preference to the artist's use of varied technical means in order to encompass meaningful content. Hopefully, while each viewer and reader of this book will have the opportunity to respond to individual works, the compilation will also lend itself to speculation and study. Are artists from Eastern European countries more likely to use rendering and pictorial illusion? Do artists from the United States favor the juxtaposition of appropriated images from popular culture? The sense of our long history and more specific lineage is certainly manifest in the work. Who studies with whom and who worked at which workshop has left its trace. Whatever your conclusions, I think you will find skill and craft used as a vehicle to communicate deep convictions and serious play.

Ruth Weisberg
Artist/Printmaker, Critic, and Dean
of Fine Arts, University of Southern
California

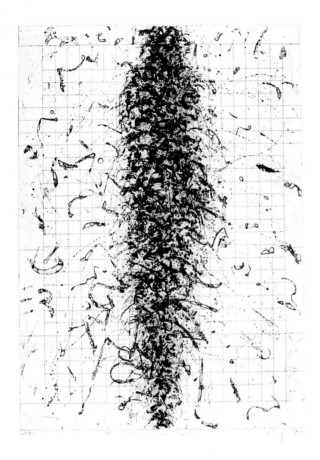

The Object of Desire

32" × 23" (81 cm × 58 cm)
Oil-based ink, Rives BFK paper
Technique: Intaglio

*This print used sugar lift, open bite,
line etching, aquatint, and soft ground
etching.*

JANE FASSE

Seeing Spots

22" × 30" (56 cm × 76 cm)
Oil-based intaglio printing inks, Rives
BFK paper
Technique: Intaglio monoprint using
up to five different steel plates

*The layers of texture and color
that dominate the artist's paintings
translate into printmaking by using
multiple-image plates that are printed
over each other in many different
combinations.*

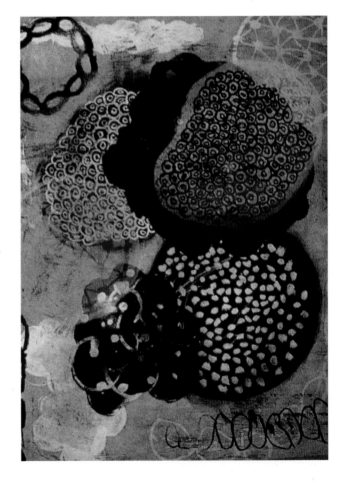

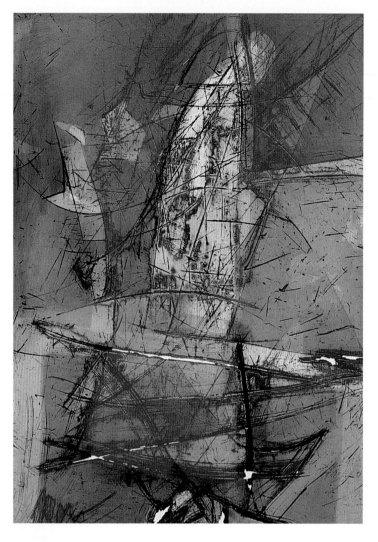

SERGEI TSVETKOV

Departure

27" × 20" (69 cm × 51 cm)
Charbonnel etching ink, Handschy
litho ink, Somerset paper (300 gsm)
Technique: Etching, monoprint

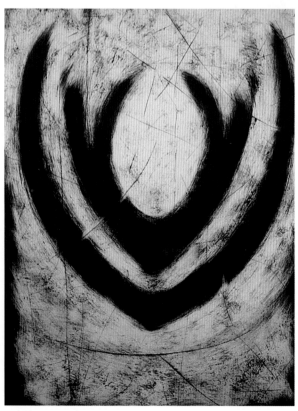

GLEN ROGERS PERROTTO

Renewal

55" × 42" (140 cm × 107 cm)
Oil-based ink on Arches cover paper
Technique: Drypoint, monoprint

*The use of ancient symbols from the
Neolithic era becomes a universal
language for the divine feminine.*

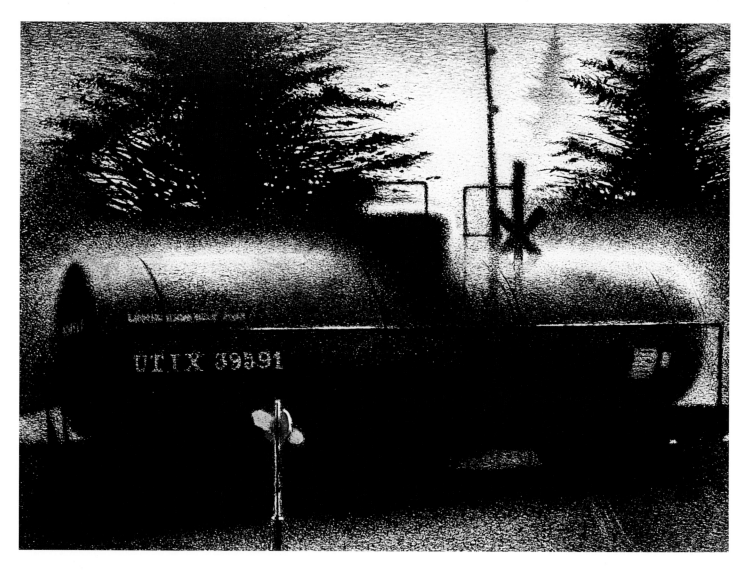

BOYD SAUNDERS

The Crossing

30" × 40" (76 cm × 102 cm)
Oil-based printer's ink, Rives BFK
paper (gray)
Technique: Stone lithograph

*The print is an investigation of tone,
atmosphere, and mood.*

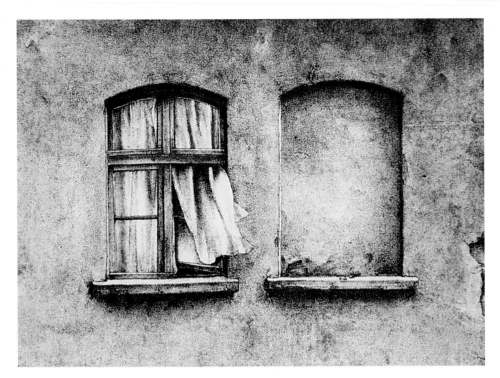

Window

29" × 20" (74 cm × 51 cm)
Charbonnel etching ink, Hahnemühle paper
Technique: Etching

JUERGEN STRUNCK

CKC-16

27" × 27" (69 cm × 69 cm)
Oil-based litho ink, Yatsuo paper
Technique: Relief, stencil

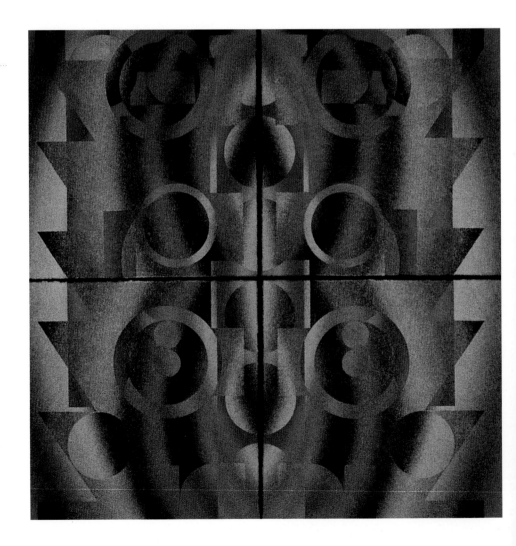

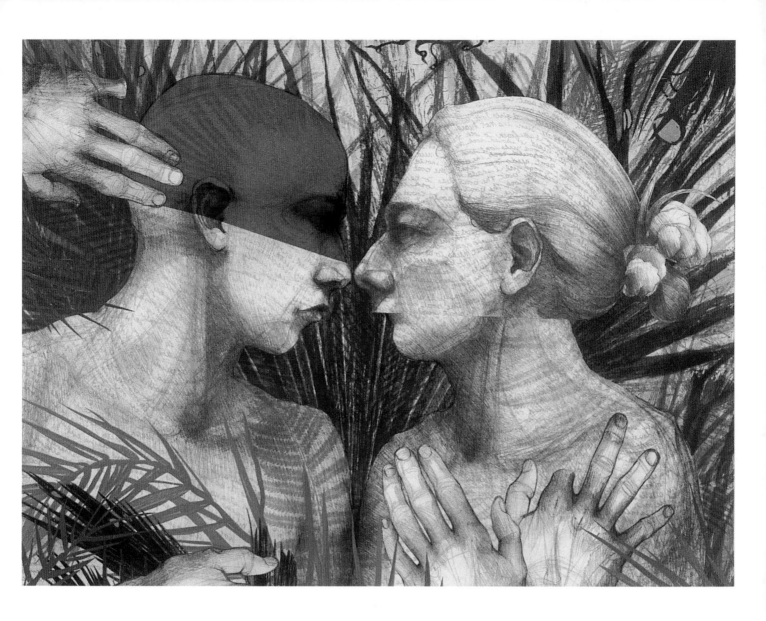

M. Kate Borcherding

Search for Truths

16" × 22" (41 cm × 56 cm)
Oil-based ink, Rives BFK paper
Technique: Lithography, relief, chine collé

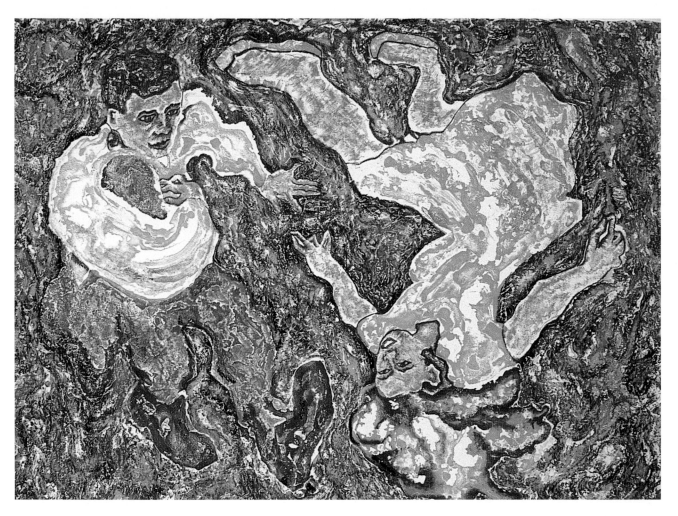

RONALD GLASSMAN

Man and Woman

22" × 32" (56 cm × 81 cm)
Litho ink, Arches paper
Technique: Stone lithography

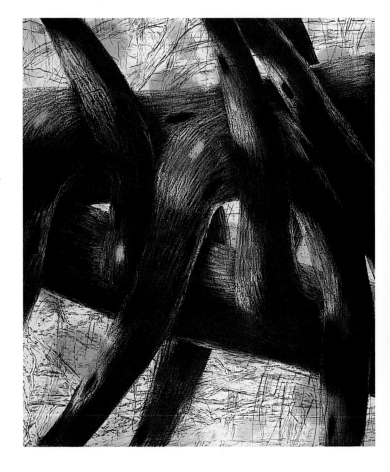

NONA HERSHEY

Branches, Spring

20" × 17.5" (51 cm × 44 cm)
Charbonnel ink, Sheng-Shuen paper,
Somerset paper (white), two copper
plates
Technique: Intaglio, chine-collé

*"Branches, Spring" represents renewal;
the dappled light and color of new
foliage animates interwined branches
in their ongoing conversation with
each other.*

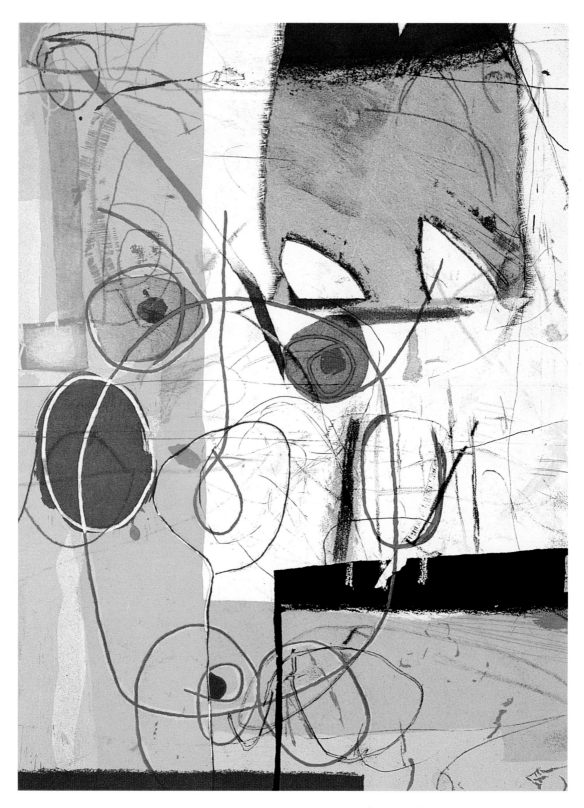

Echo

16" × 12" (41 cm × 30 cm)
Oil-based inks, Rives BFK paper (white)
Technique: Intaglio aquatint, hard ground,
soft ground

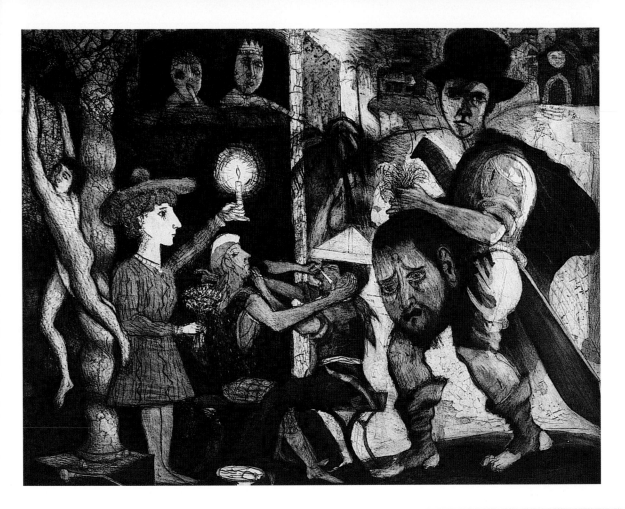

DAVID F. DRIESBACH

A Manicheist Dream

18" × 24" (46 cm × 61 cm)
Rives BFK paper (250 gsm)
Technique: Intaglio, etching, engraving,
soft ground, aquatint

*This is the artist's response to
Picasso's "Minotauromachy."*

NAOHIKO WATANABE

96-1-2

44" × 30" (112 cm × 76 cm)
Oil-based ink, Somerset paper
Technique: Screen print

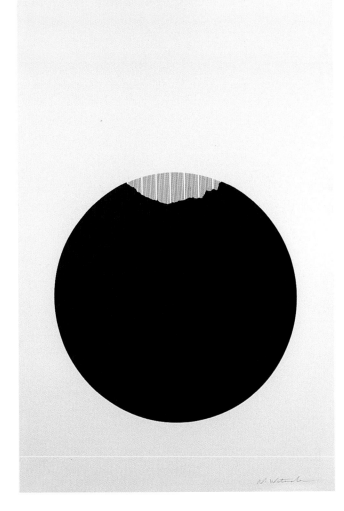

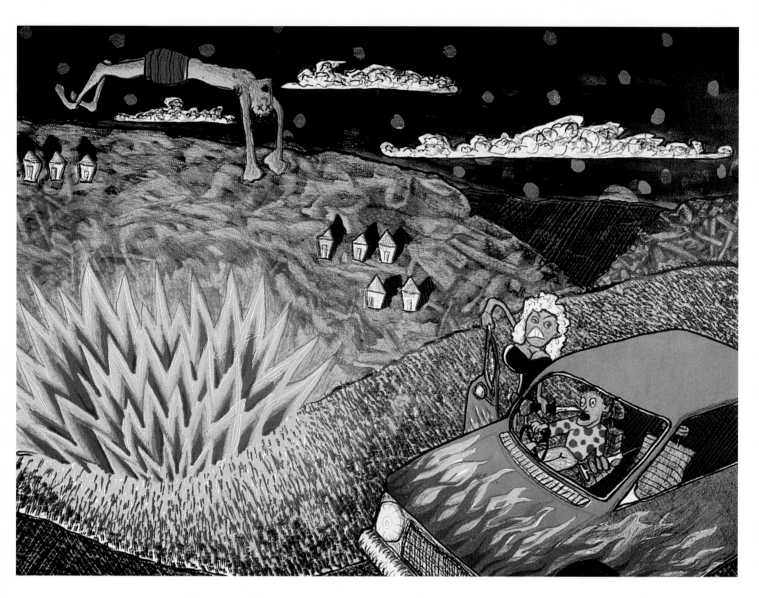

S T A N L E Y K A M I N S K I

Rest Stop

15.5" × 22" (39 cm × 56 cm)
Oil-based Handschy ink, Rives BFK
paper
Technique: Lithography (four color
runs)

*"Rest Stop" is a four-color lithograph
about making bad decisions in life; it
is a social commentary.*

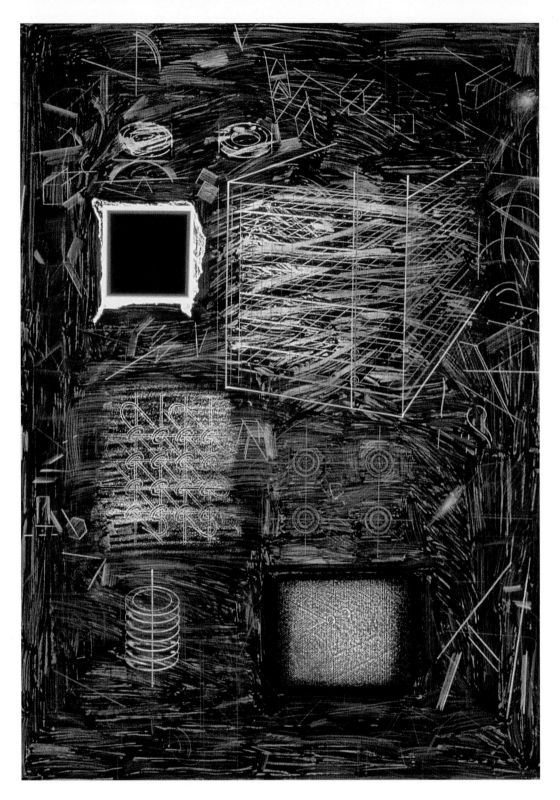

JACK DAMER

History Lesson

36" × 24" (91 cm × 61 cm)
Oil-based litho ink, Rives BFK paper
Technique: Lithography, colored pencil
additions

Isolated elements in this print represent formal devices used historically to make art; the elements are on different levels of the plane.

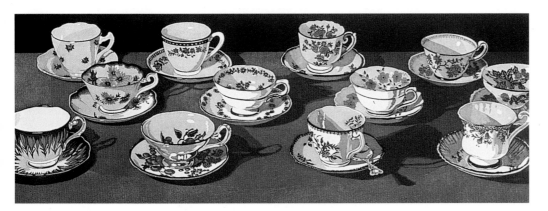

Tea for Twelve

11.5" × 30" (29 cm × 76 cm)
Oil-based etching ink, watercolor,
Rives BFK paper (100% rag), copper
plate
Technique: Etching, aquatint on
copper, multiple color plates, hand
coloring with watercolor

*The artist likes to think of a still life
as a stage in which the characters
come to life and interact.*

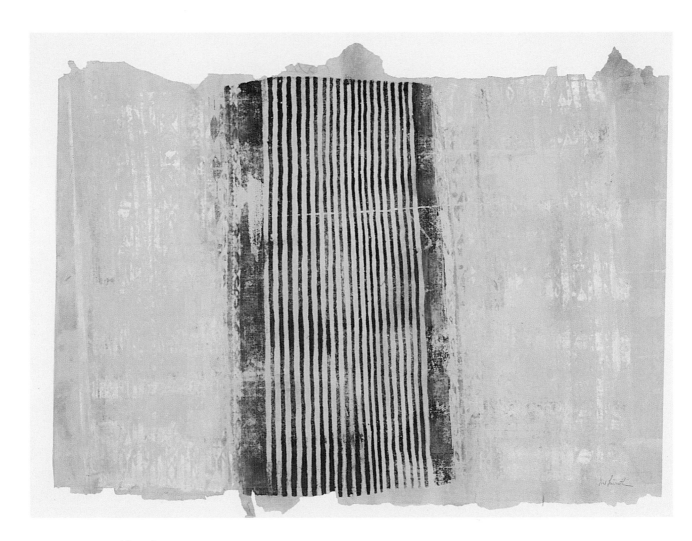

MIL LUBROTH

Heartstrings

24" × 36" (61 cm × 90 cm)
Water-based ink (bon à tirer)
Technique: Silk-screened on manila
construction paper

*Lubroth's work primarily deals with
the interrelationship of varied cul-
tures, past and present.*

WAYNE MIYAMOTO

Haniwa—Constellation

24" × 18" (61 cm × 46 cm)
Oil-based ink, Rives BFK paper
Technique: Intaglio, sugar lift, line
etching, aquatint, and multiple soft
ground etching.

BRIAN PAULSEN

Bridging Buildings

9" × 13" (23 cm × 33 cm)
Oil-based ink, Morilla paper
Technique: Plastic engraving

*This subject of the print is the early
days of television viewing in an old
Seattle neighborhood.*

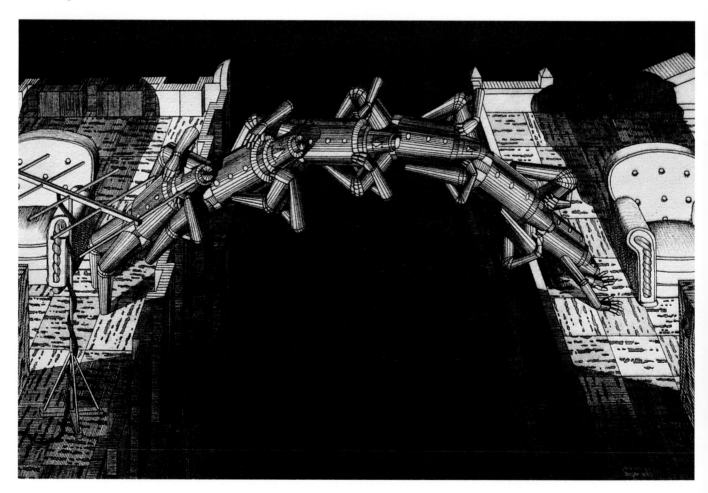

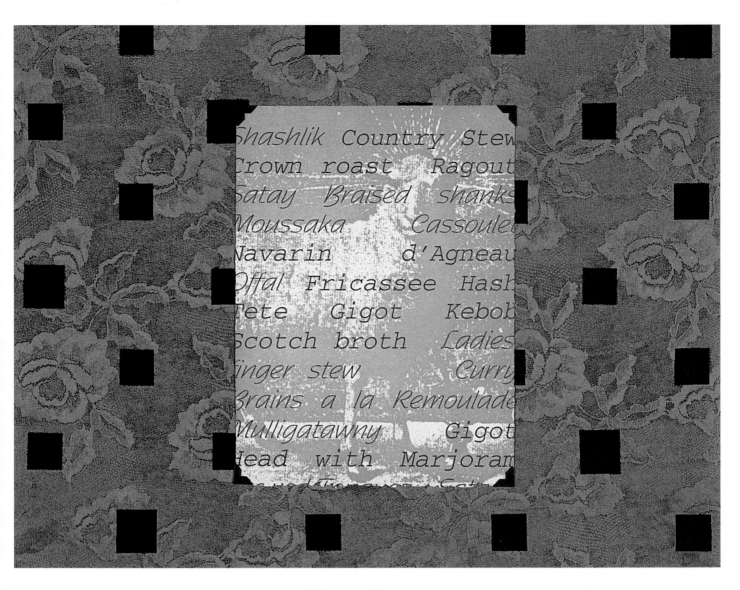

FRANCES MYERS

Favorite Recipes

15" × 20" (38 cm × 51 cm)
Etching ink, Rives BFK paper (white
and gray), photo corners
Technique: Intaglio, computer-generated
art

*"Favorite Recipes" is part of a series
of images referring to daily rituals
enhanced by paraphernalia that adds
to the significance of an event or
practice, and at the same time
removes participants from the mun-
dane and sometimes repugnant ori-
gins of those items. Thus, elaborate
cookbooks, menus, and linens dis-
tance one from the reality of animal
meat slaughter. The artist tries to
bring both parts of the equation to
the table.*

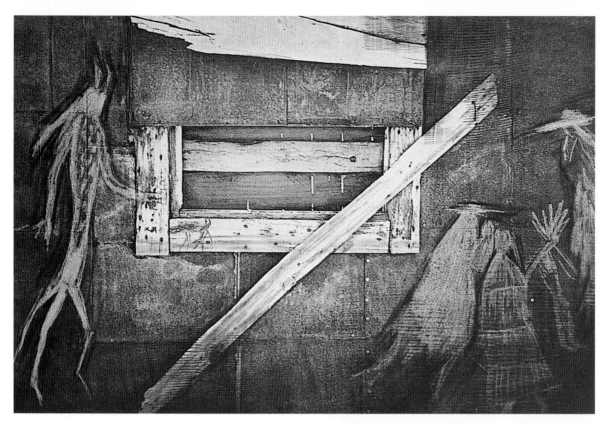

VEERLE ROOMS

Spirit of Bagdad Cafe

8" × 12" (20 cm × 30 cm)
Etching ink, Hahnemühle etching
paper
Technique: Intaglio, heliogravure

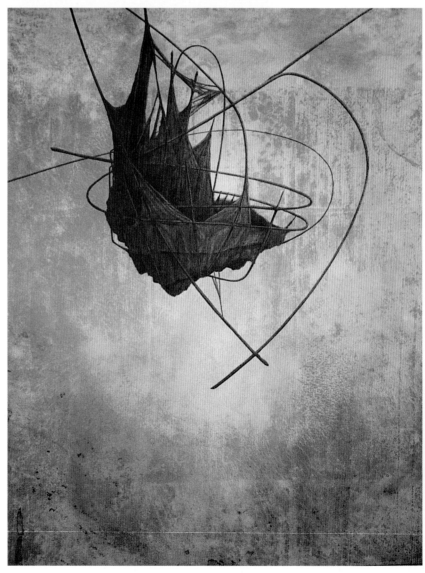

MICHAEL D. BARNES

Transport

30" × 22" (76 cm × 56 cm)
Oil-based ink, Rives BFK paper
Technique: Lithography (stone and
plate), etching

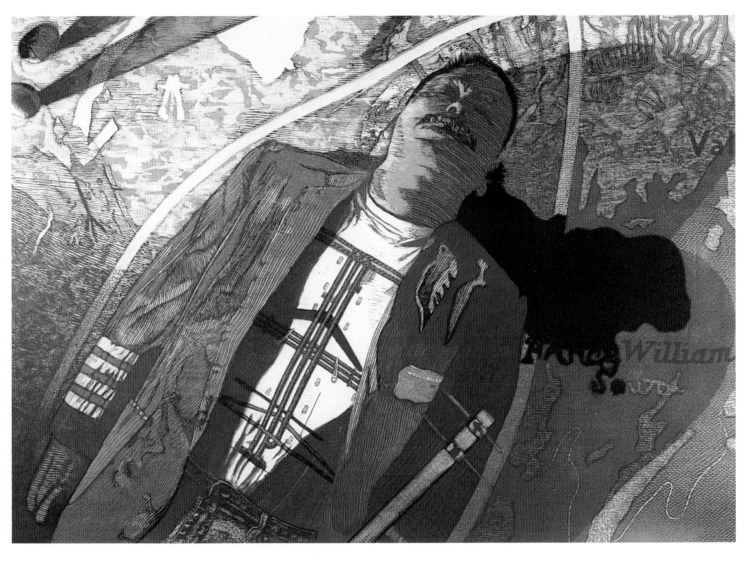

MARK D. SISSON

Portrait of R. Bivins/Exxon Marks the Spot II

20" × 30" (51 cm × 76 cm)
Oil-based relief ink, Torinoko paper
Technique: Woodcut/monoprint combination; printed from one block of shina plywood and one sheet of Plexiglas; five colors were used.

This piece is based on the notion that oil and water don't mix; it asks the question: Which is more important, oil in our gas tanks or potable water in our faucets?

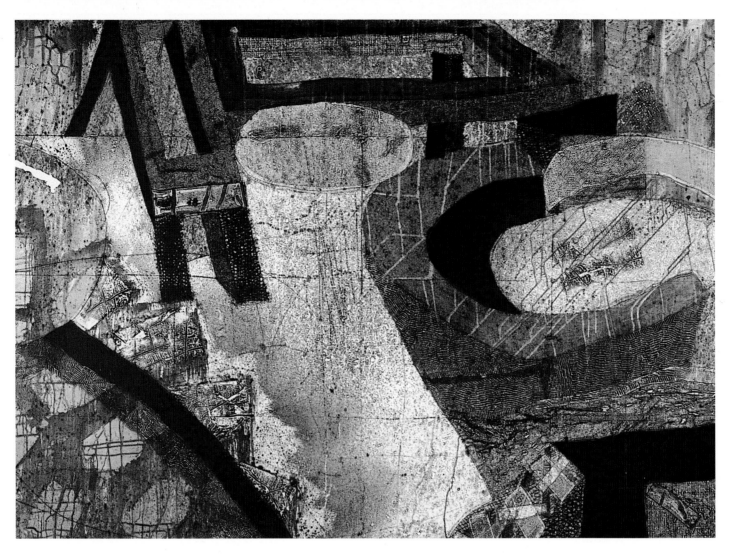

PETER MARCUS

#4

60" × 84" (152 cm × 213 cm)
Oil-based etching ink, Somerset paper
Technique: Collagraph and intaglio
prints, glued to canvas, stretched and
coated with Rhoplex

*These images are based on Roman
ruins as the Roman Empire moved
from Italy to Ireland and across
Europe.*

RAY E. GEORGE

6/28/95

18" × 24" (46 cm × 61 cm)
Oil-based ink, Rives BFK paper
Technique: Collagraph

JACK DAMER

Flak

36" × 24" (91 cm × 61 cm)
Oil-based litho ink, Arches Cover
paper
Technique: Lithography, cut-away,
collage

*The use of military projectiles is the
print's subject matter—beauty vs.
fear; the center of the print is a photo
reproduction of the total piece.*

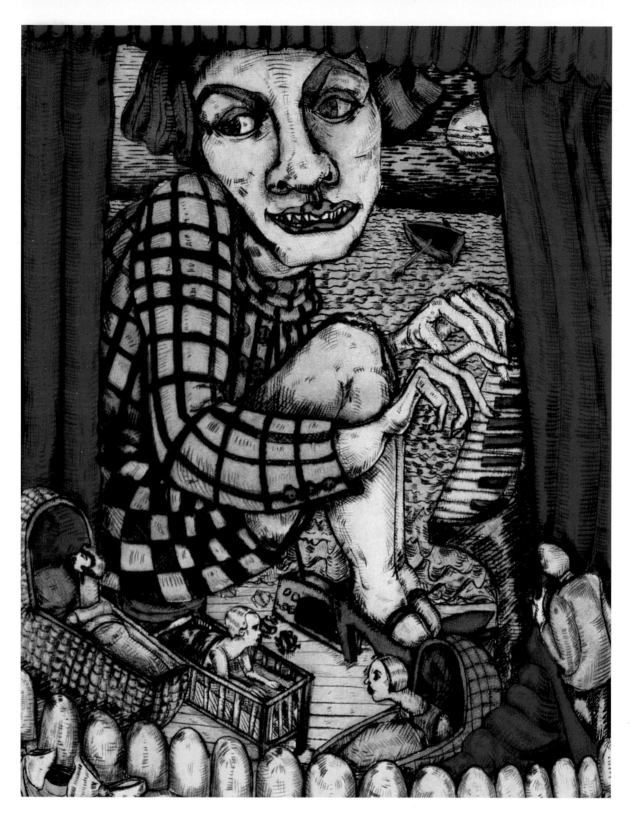

JULI HAAS

Cry Baby Cry

12" × 10" (30 cm × 25 cm)
Oil-based Graphic Chemical etching
ink (blue-black), Hahnemühle paper
Technique: Intaglio, drypoint, water-
color

*A discordant lullaby is played to
child-like figures in their cribs; the
mother's song is ambiguous in intent,
reflecting on past sorrows or warning
of future woes.*

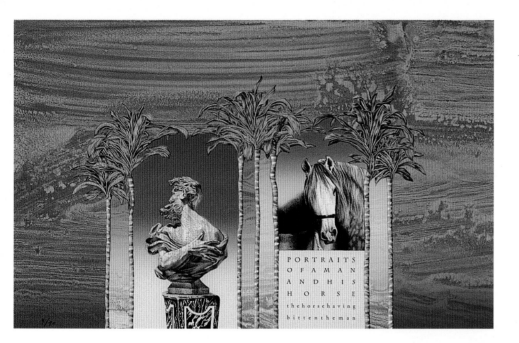

PORTRAITS OF A MAN AND HIS HORSE
the horse having bitten the man

9" × 15" (23 cm × 38 cm)
Offset ink, Rives BFK paper (gray)
Technique: Lithography, crayon, wash, flats, blends

This double portrait is intended to convey the dynamic personalities of both the supposed master and his less-than-submissive mode of transportation.

ARTHUR WATSON

Across the Sea

204" × 440" × 144" (518 cm × 1117 cm × 366 cm)
Vinyl-based ink, PVC
Technique: Screenprint sewn and mounted on wood, steel, and rope structures

These fishermen's smocks suggest the sunset of the Scottish fishing industry. It was created for the Venice Biennale.

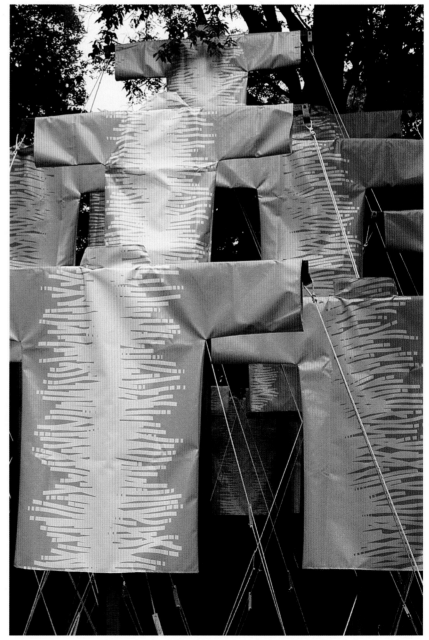

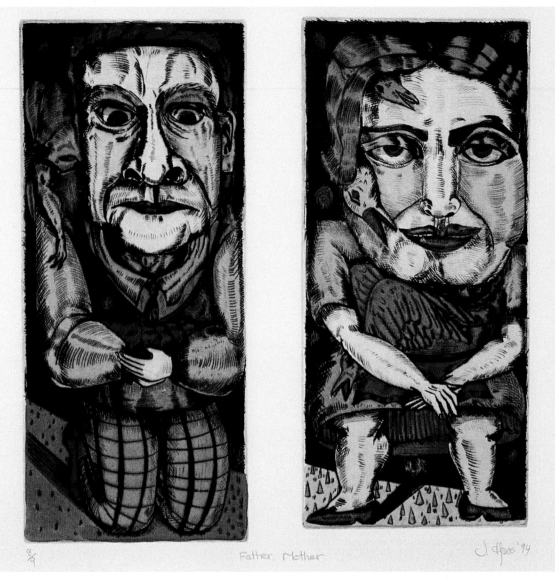

Father, Mother

J. Haas '94

JULI HAAS

Father, Mother

25" × 11" (64 cm × 28 cm)

Oil-based Graphic Chemical etching ink, Hahnemühle paper

Technique: Intaglio, drypoint, water-color

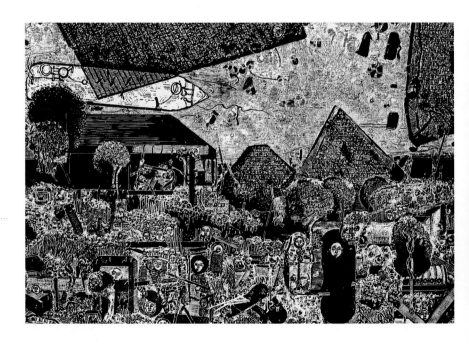

FLORIN HATEGAN

My World 1

21.5" × 29" (55 cm × 74 cm)

Oil-based ink

Technique: Linocut

BERT MENCO

Suitors 1994

24" × 18" (61 cm × 46 cm)
Oil-based ink, Rives BFK paper (gray)
Technique: Etching, aquatint, roulette;
yellow background is aquatinted

*Part of a suite of nine prints (the
"Interaction Suite," all dealing with
personal relationships), this image
shows a princess being courted and
carried away.*

BEAUVAIS LYONS

Aazudian Implements, Plate 37

14" × 11" (36 cm × 28 cm)
Litho ink, Somerset Antique paper
Technique: Stone and plate color
lithograph

*The print parodies 19th-century
lithography to document artifacts
from imaginary Mesopotamian
cultures; this work is part of an
interdisciplinary approach which
encompasses painting, sculpture,
ceramics, performance, and
exhibition design.*

DEREK MICHAEL BESANT

Amnesia/Lost in the Northern Territory

13.5" × 31.5" (34 cm × 80 cm)
Water-based ink, Rives BFK paper
(100% rag)
Technique: Serigraph in colors on two
decal paper, chine collé, bleed image

*This image is about remembering and
forgetting; it shows a purposefully
out-of-focus face; part of a topo-
graphic map (territory); a piece of the
everyday world—a lost object...; part
of a series for Paris/Fin-De-Siecle.*

JUDITH PALMER

Construction V

18" × 24" (46 cm × 61 cm)
Printer's ink, oil color, Arches paper
Technique: Photo-etching

*Palmer works with and explores the
content inherent in line and texture—
the sign system within art; she uses
photo-etching techniques that capture
"found language" from streets, walls,
and discarded papers.*

KONSTANTIN CHMUTIN

Still Life VI, 1993

5" × 8" (13 cm × 20 cm)
Charbonnel etching ink, Barcham
Green etching paper, gampi paper
Technique: Mezzotint, chine collé

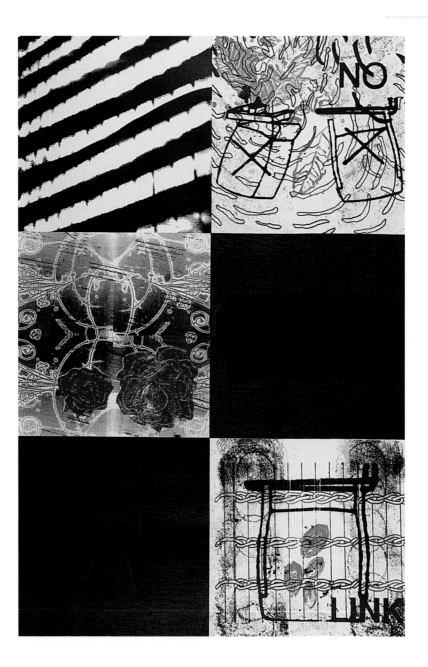

HELEN C. FREDERICK

No Link

42" × 25" (107 cm × 64 cm)
Oil-based litho ink, June Wayne cotton
rag paper, Kozo paper (blue)
Technique: Lithography, chine collé

YUJI HIRATSUKA

Slip of Memory

18" × 24" (46 cm × 61 cm)
Koradani washi paper, Rives BFK
paper
Technique: Intaglio, relief, chine collé

ELAINE SHEMILT

The Pale Washerwoman

36" × 25" (91 cm × 64 cm)
Intaglio ink, Hahnemühle paper
Technique: Intaglio (photo-etching)

This is one of a series of 24 prints illustrating the Schönberg Pierrot Lunaire Sonnets.

JUDITH K. BRODSKY

Wears Jumpsuit, Sensible Shoes

24" × 36" (61 cm × 91 cm)
Etching ink, Rives BFK paper
Technique: Intaglio: Aquatint, photo-etching, chine collé

These images refer to how most women are given identity through their clothes, unlike men, whose identity depends on other characteristics.

Heroic Visit: New Age Flags

22" × 15" (56 cm × 38 cm)
Oil-based ink, Rives paper
Technique: Lithography

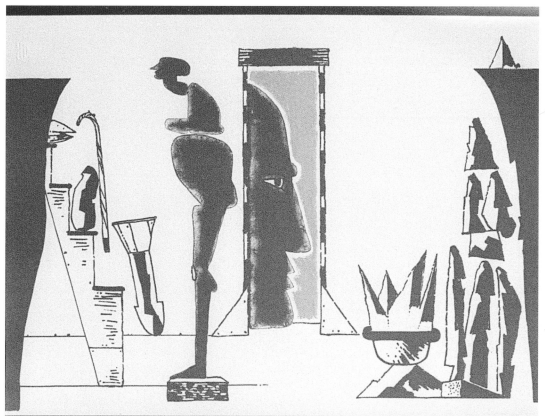

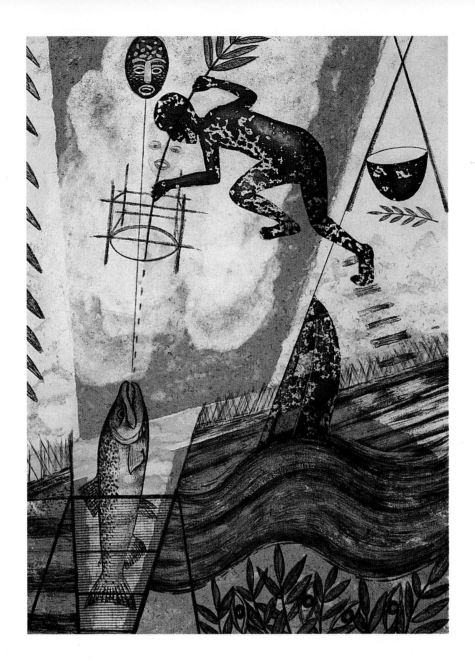

MARGARET H. PRENTICE

Fishing

30" × 22" (76 cm × 56 cm)
Oil-based ink, handmade paper (abaca),
pigmented pulp
Technique: Intaglio

*"Fishing" was inspired by petroglyphs
engraved in rock walls; the color in the
print represents rock stratification.*

JEFFREY L. SIPPEL

No Drops

22" × 29" (56 cm × 74 cm)
Hanco oil-based paper, Rives BFK
paper (white)

*The artist approaches the work by
working negatively from light to dark.
Beginning with a basic, easily recog-
nized image in mind, the artist allows
the subtractive process to provoke
new interpretations.*

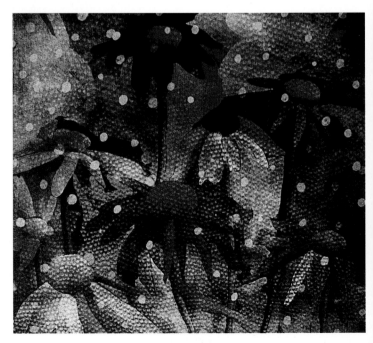

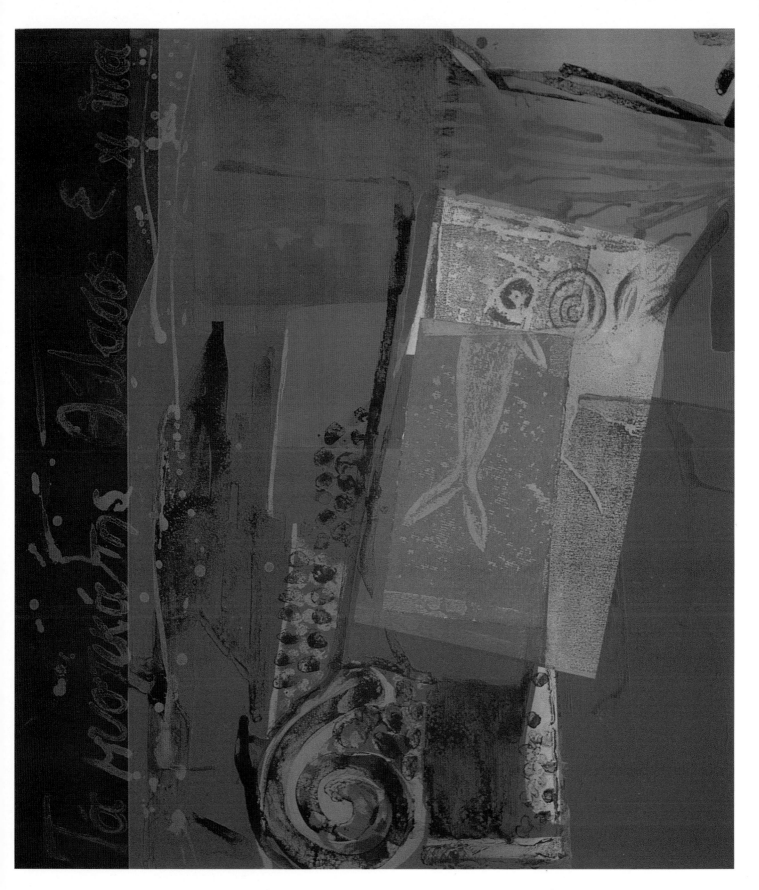

ELSPETH LAMB

Anaktos

50" × 47" (127 cm × 119 cm)
Litho inks, Arches Velin paper (white)
Technique: Lithography, chine collé

*This work's title translates as "Of the
living river Nile."*

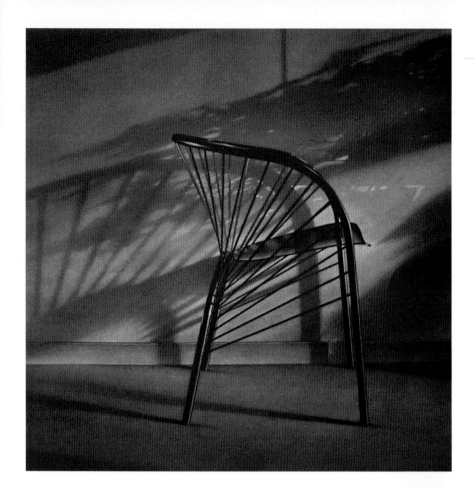

ANNE DYKMANS

Ondes ("Waves")

12.5" × 12.5" (32 cm × 32 cm)
Charbonnel ink (55981, black),
Zerkall-Bütten 902 paper
Technique: Intaglio, mezzotint,
aquatint

VEERLE ROOMS

Oedmoeder

15.5" × 11" (39 cm × 28 cm)
Oil-based etching ink, Hahnemühle
etching paper
Technique: Intaglio etching

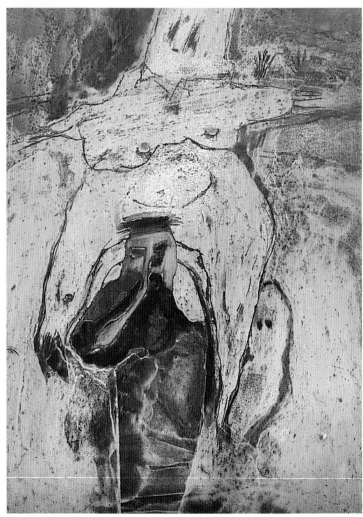

SIEGFRIED OTTO
HÜTTENGRUND

Nightmare

27.5" × 14" (70 cm × 36 cm)
Technique: Color wood engraving

SUSAN J. GOLDMAN

Cyclades

22" × 36" (56 cm × 91 cm)
Oil-based litho ink, Arches 88 paper
Technique: Multi-drop monotype

DAWN MARIE GUERNSEY

Untitled

24" × 18" (61 cm × 46 cm)
Etching ink, Rives BFK paper,
copper plate
Technique: Intaglio

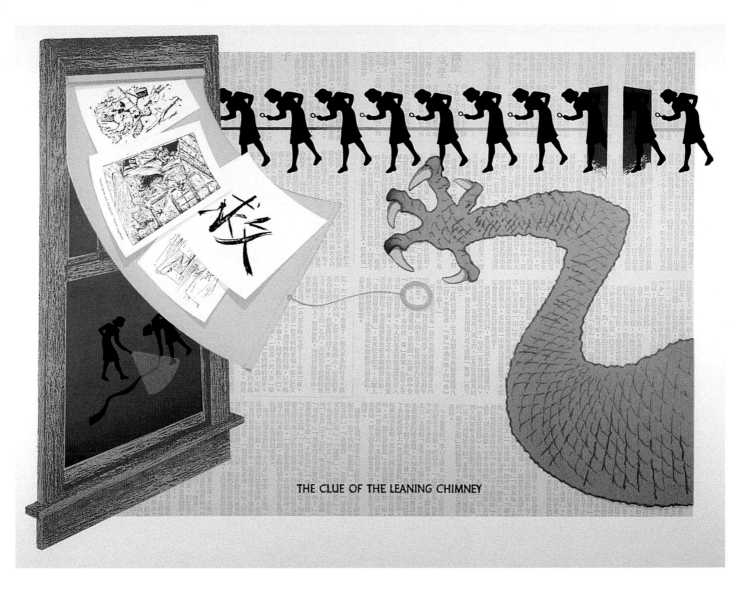

THE CLUE OF THE LEANING CHIMNEY

LAURA RUBY

The Clue of the Leaning Chimney

22" × 30" (56 cm × 76 cm)
Oil-based ink, Rives BFK paper
Technique: Serigraph

This print is a cross-cultural puzzle; in the upper floor of an American balloon-frame house, on wallpaper from a Chinese newspaper, the Chinese character for "Help!" commands the viewer to make haste and to take action.

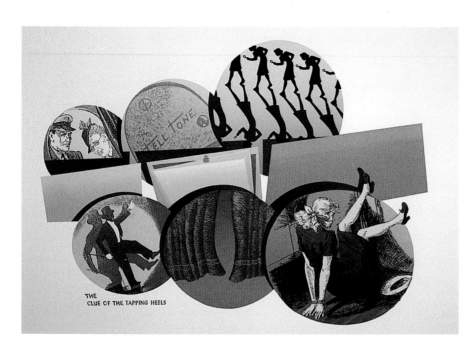

LAURA RUBY

The Clue of the Tapping Heels

22" × 30" (56 cm × 76 cm)
Oil-based ink, Rives BFK paper
Technique: Serigraph

This print employs images and references from popular culture and communication codes. As an early frontispiece image of Nancy Drew taps out her cry for help, a visual echo is provided by the dominant graphic of Morse code (·····--·).

CAROL S. FITZSIMONDS

Shades of Summer

7" × 8" (18 cm × 20 cm)
Oil-based Charbonnel, Faust, and Graphic Chemical etching ink, Somerset Textured paper (250 gsm)
Technique: Intaglio, traditional rosin aquatint on zinc plate

"Shades of Summer" captures the sultry light of a Charleston, South Carolina summer; FitzSimonds survived five such summers by doing as little as possible—which is the reason behind the chair image.

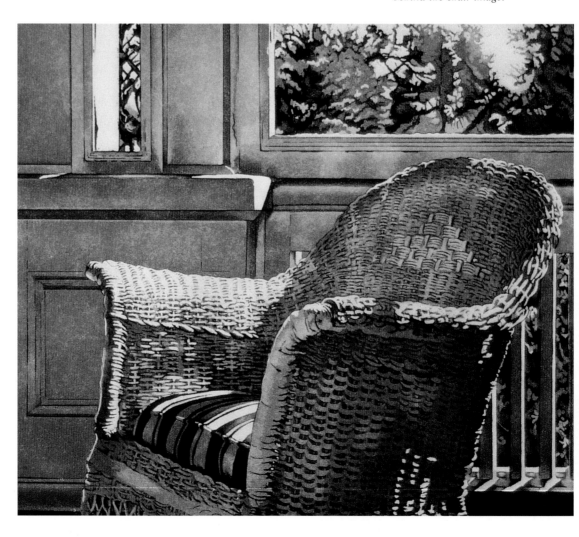

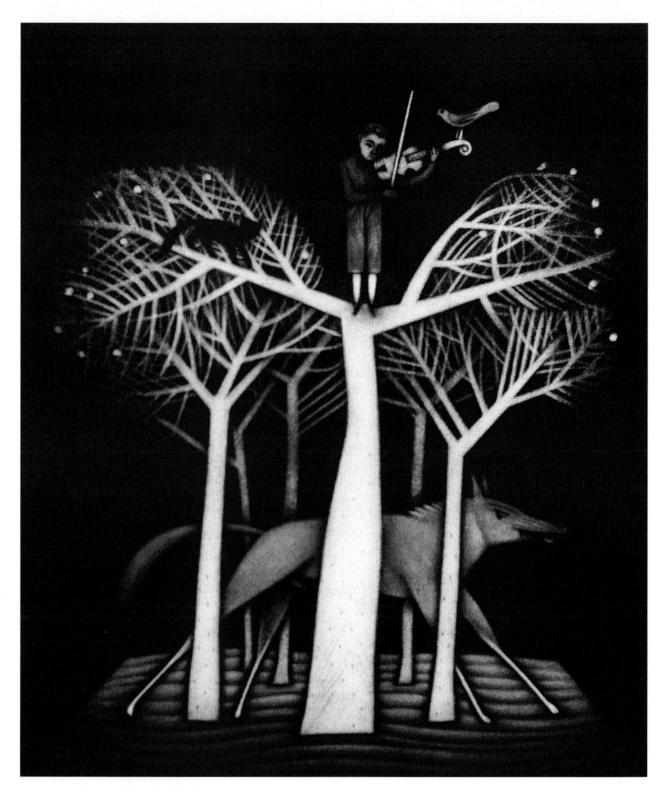

ROGER HARRIS

Peter and the Wolf

10" × 8.5" (25 cm × 22 cm)
Fabriano Tiepolo paper
Technique: Mezzotint, two plates,
five colors

Harris likes the influence music has on
how we see; a line he came across—
"The music of what happens"—seemed
to sum up "Peter and the Wolf."

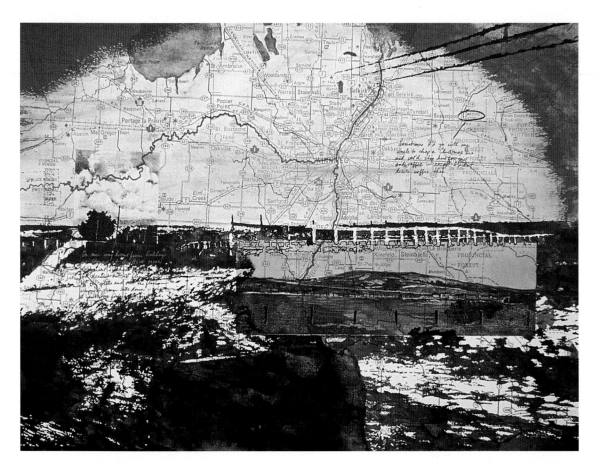

MARGARET DOELL

Southern Manitoba

22" × 30" (56 cm × 76 cm)
Oil-based Handschy litho ink, Rives
BFK paper, Japanese Tosa paper
Technique: Lithography, chine collé

*This piece works with ideas of memory
and layers maps, stories, and visual
images to link place with identity.*

DON F. CORTESE

*Epipoli (from the "Italian Journal"
series)*

24" × 24" (61 cm × 61 cm)
Oil-based intaglio and relief inks,
handmade paper, collage materials
Technique: Intaglio, photography

*"Epipoli" integrates the concept of
narrative as a basis for presentation
of similar and disparate materials;
tiling and sequencing are currently a
constant process in organizing the
work. Handmade paper is not only a
substrate, but an integrated process in
the artist's exploration of image and
technique.*

K.C. JOYCE

Courtyard

22" × 30" (56 cm × 76 cm)
Oil-based Handschy ink, Somerset
paper (black, 100% rag)
Technique: Monotype

KATE LEAVITT

Thinking of You

29" × 22" (74 cm × 56 cm)
Graphic Chemical and shop mix ink
(black), Fabriano Magnani Incisioni
paper (cream)
Technique: Lithography

*Leavitt's prints contain images that
create tensions between isolated icons
and symbols, spatial disorientation,
illusions of objects, and references to
specific personal events.*

YOSHIKO SHIMANO

Invitation to Heaven

119" × 133" (302 cm × 337 cm)
Oil-based ink, Stonehenge paper
(gray), Arches paper (black)
Technique: Woodcut and Charcoal on
paper (reduction printing)

Photo by Tadahisa Sakurai

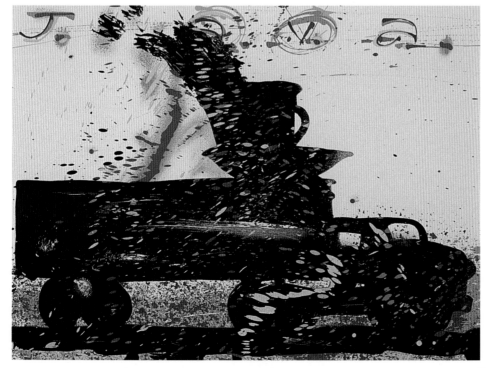

RICHARD M. ASH

J.A.V.A., 1996

14.5" × 20" (37 cm × 51 cm)
Oil-based screenprinting ink,
Stonehenge paper (white)
Technique: Reduction screenprint in 16
colors, using two screens

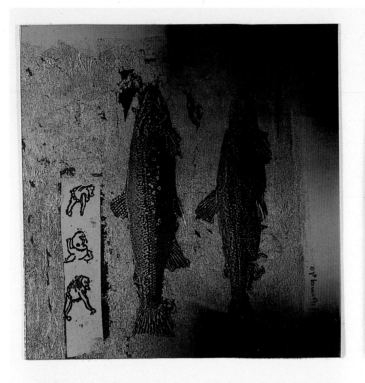
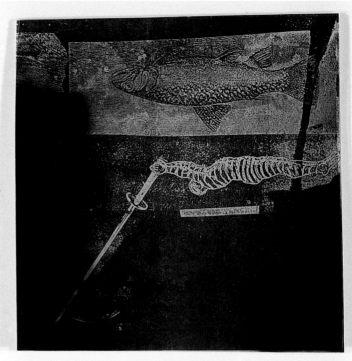
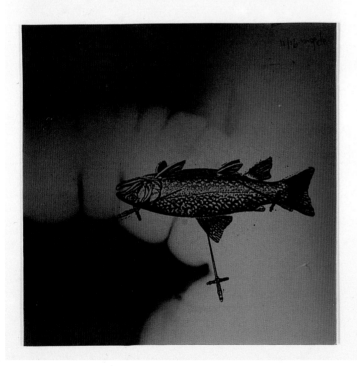
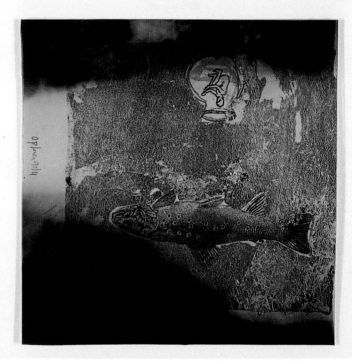

GEERT OPSOMER

Vis "A" ("Fish 'A'")

6" × 6" (15 cm × 15 cm)
Oil-based ink on Rives BFK paper
Technique: Lithography, etching, X-ray,
silver-leaf

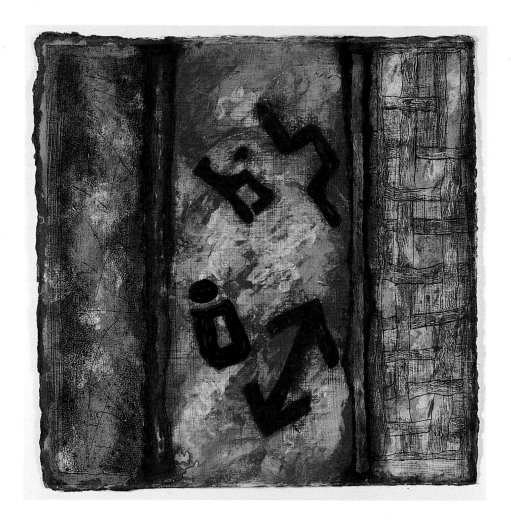

To Bear Witness

40" × 30" (102 cm × 76 cm)
Oil-based ink, Kozo paper, four-hour beaten pigmented cotton rag pulp (abaca)
Technique: Pulp painting, woodcut on handmade paper

The Tibetan images and symbolism experienced during a trip to "The Roof of the World" inspired this series of woodcuts.

Natural History

13" × 27" (33 cm × 69 cm)
Arches litho ink, water-based textile ink
Technique: Metal-plate acid-tint lithography, photo silkscreen

"Natural History" uses a didactic format to express what is becoming extinct in human nature.

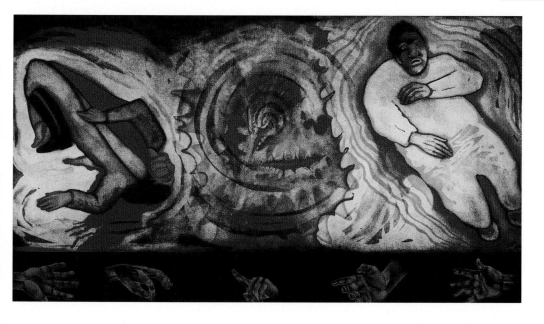

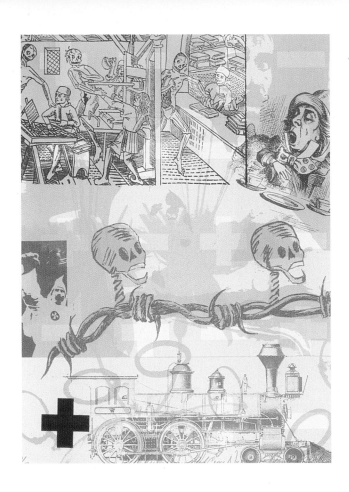

GORDON FLUKE

Cherry Ames, Red Cross Nurse

11" × 14" (28 cm × 36 cm)
Water-based ink, Arches 88 paper
Technique: Screenprint

A self-portrait is not always a representation of one's physical appearance; sometimes a representation or collage of ideas, thoughts, and objects is a more accurate depiction.

CHIPPA SUDHAKAR

A Woman in Dream

13" × 11" (33 cm × 28 cm)
Printing ink, handmade paper
Technique: Intaglio, stencil-cutting

Sudhakar's prints show his ideas regarding the life experience of the poor rural people.

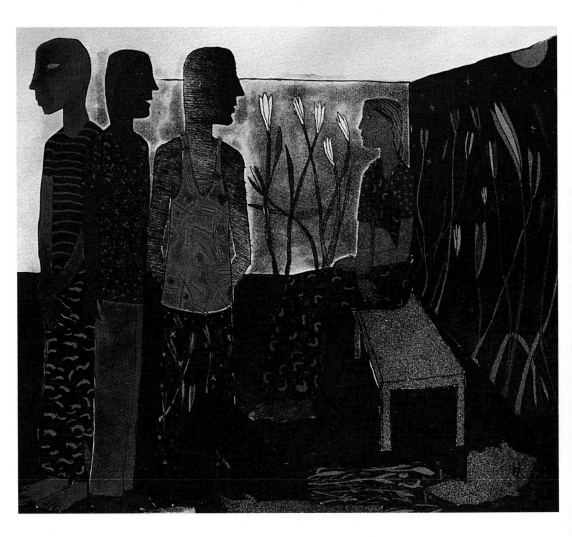

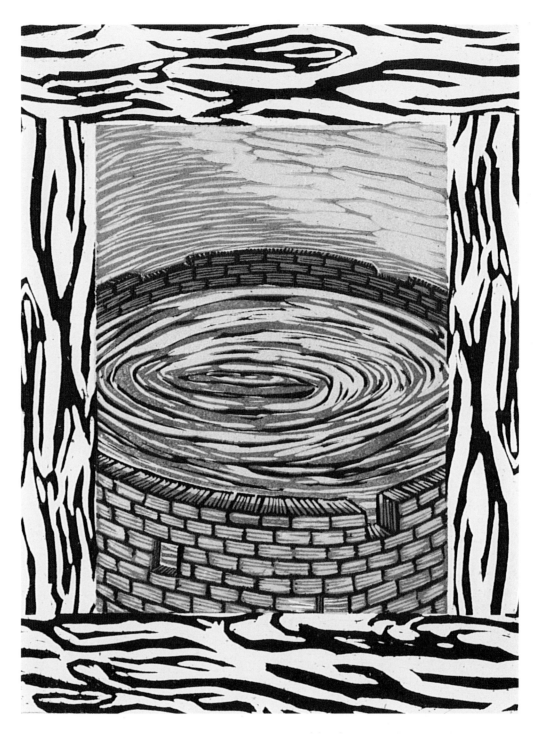

SUSAN MACKIN DOLAN

Basic Requirements for Life: Water

11" × 14" (28 cm × 36 cm)
Oil-based litho ink, handmade paper
(raw cotton)
Technique: Reduction linocut

These images recall many levels of human experience and symbolize particular properties of the mind and the intuitive operations of the spirit and the unconscious.

JIM PATTISON

Echo

22" × 26" (56 cm × 66 cm)
Oil-based etching and relief ink, Arches
and Japanese paper
Technique: Intaglio (two plates), sol-
vent transfer, chine collé, monoprint

*This image is part of a series of work
based on time the artist spent in
Vienna, and considers formal aspects
of the place.*

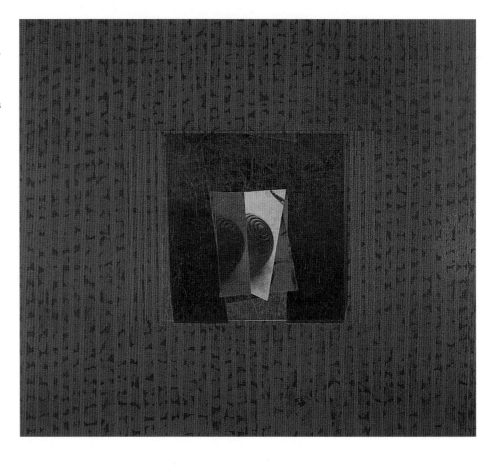

GEORGE WALKER

Collective Ideas

11" × 15" (28 cm × 38 cm)
Oil-based ink, water-developing poly-
mer relief plates, cast lead symbols
Technique: Linocut relief, computer-
manipulated polymer relief plate

*Our culture is changing—the computer
is changing the way we communicate
globally and interpersonally: We are
quickly becoming a global culture of
one mind.*

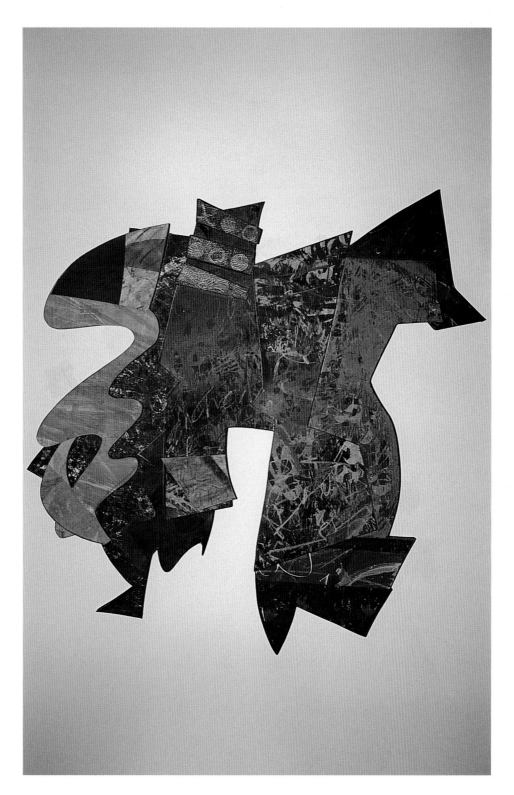

THOMAS H. MAJESKI

Ashland 23/Perceptions of China

37" × 37" × 2" (94 cm × 94 cm × 5 cm)
Litho and etching ink, water-based
crayons, oil crayons, Rives BFK paper,
museum board, gatorboard, wax
Technique: Monotype, relief, collage

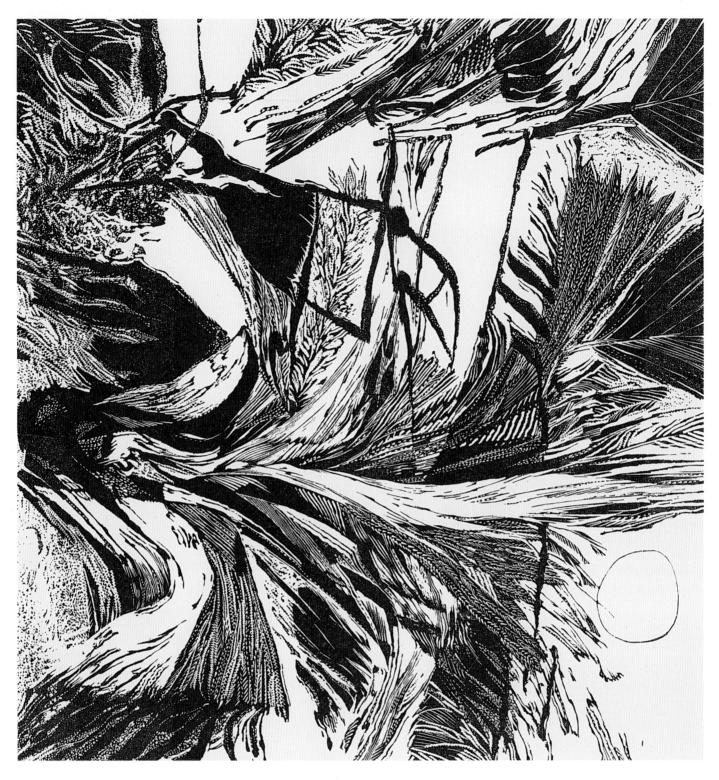

TATE ADAMS

Palm Landscape I

10.5" × 11" (27 cm × 28 cm)
Lawrence engraving ink, Arches Satin
paper (100% cotton rag)
Technique: Wood engraving

*This print is the artist's response to
the tropical landscape of North
Queensland.*

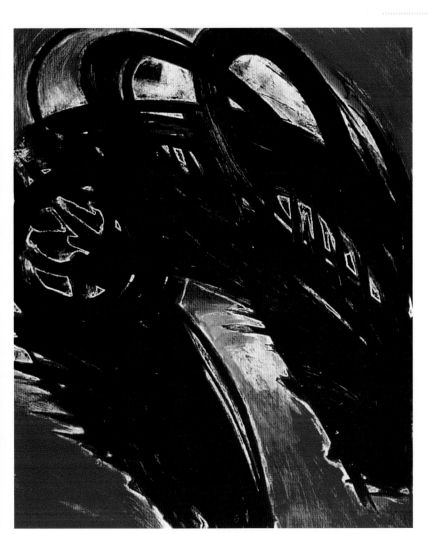

The Catch, Four

36" × 30" (91 cm × 76 cm)
Oil-based intaglio inks, Lenox paper
Technique: Viscosity-printed intaglio

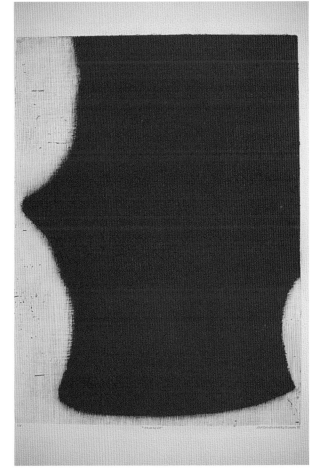

SERGIO GONZALEZ-
TORNERO

Noch Noch

21" × 16" (53 cm × 41 cm)
Oil-based printing ink (cadmium red),
Arches Cover paper, zinc plate
Technique: Intaglio, drypoint with a
scraper

*With the plate clamped to a table, the
artist worked sculpturally with a
sharp scraper (using both the point
and the edge), seeking a drypointed
form which when inked with red
prints a vital, luminous, transcenden-
tal mass on modulated white space.*

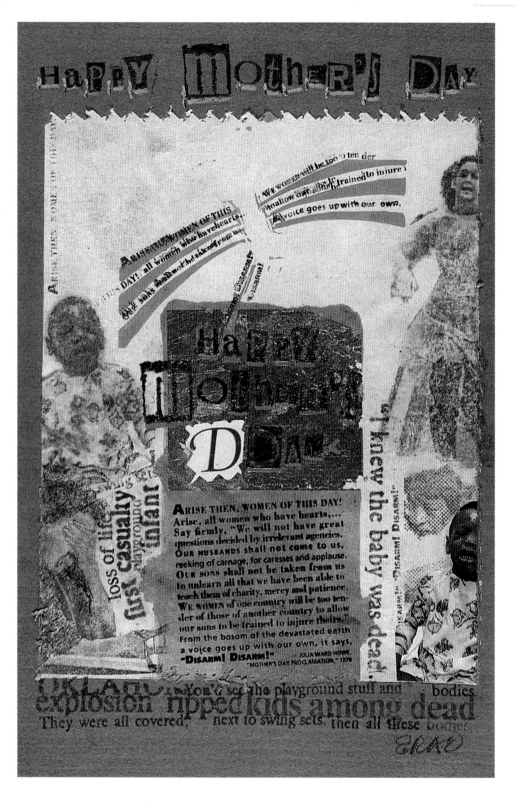

Happy Mother's (D) Day

8" × 6" (20 cm × 15 cm)
Water-based ink (orange), gouache,
oil-based transfers, Chinese napkin
with gold foil, Fabriano Italia paper
Technique: Linocut, ink transfer
from newsprint and from computer-
generated type

*Less than one month before Mother's
Day 1995, families and friends were
suddenly ripped apart in the
Oklahoma City bombing. "Happy
Mother's (D) Day" was Erena Rae's
reaction to the violence.*

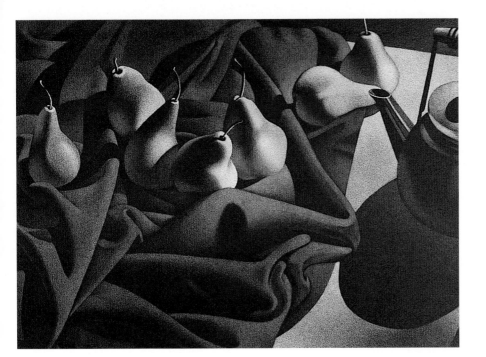

WILLIAM BEHNKEN

Pears

18" × 24" (46 cm x 61 cm)
Graphic Chemical oil-based ink (#5A),
Rives BFK paper (gray)
Technique: Intaglio, aquatint

SANDY SYKES

Big Bad Wolf

56" × 42" (142 cm × 107 cm)
Oil-based commercial, litho, relief and
etching ink, Khadi handmade Indian
rag paper
Technique: Hand-rubbed, multilayered
and collaged woodcut

*The sources of folk stories (such as
"The Three Little Pigs") reflect
human/animal survival and interde-
pendence through history; constructed
ecological paper and the transparency
of imagery and surface represent time
and change in the image.*

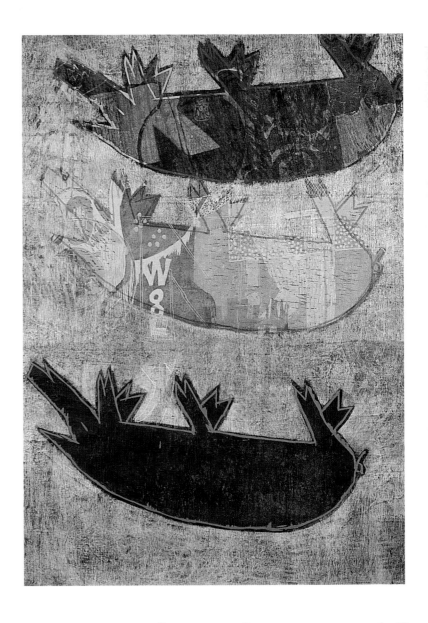

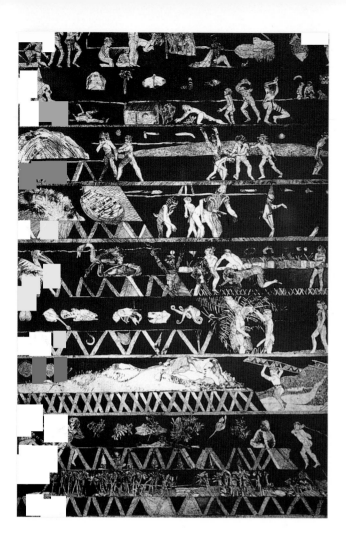

RON McBURNIE

The Bridge Night

35.5" × 23.5" (90 cm × 60 cm)
Oil-based ink, Arches Rives BFK
(300 gsm)
Technique: Intaglio

This etching was based on the lives of the aboriginal people, known as "bridge people," who lived under Louthes Bridge in Townsville, Australia.

ALAN AZHDERIAN

Holiday Environs

22" × 30" (56 cm × 76 cm)
Oil-based ink, Rives BFK paper
Technique: Monoprint

Azhderian began his work with an undirected process of mark-making: the drawing progresses as relationships interact, shaped by their activity and conjunction; eventually a sense of connectedness, an emerging narrative comes forth.

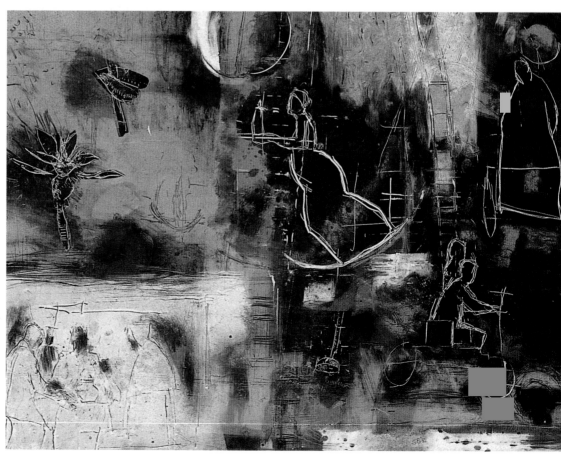

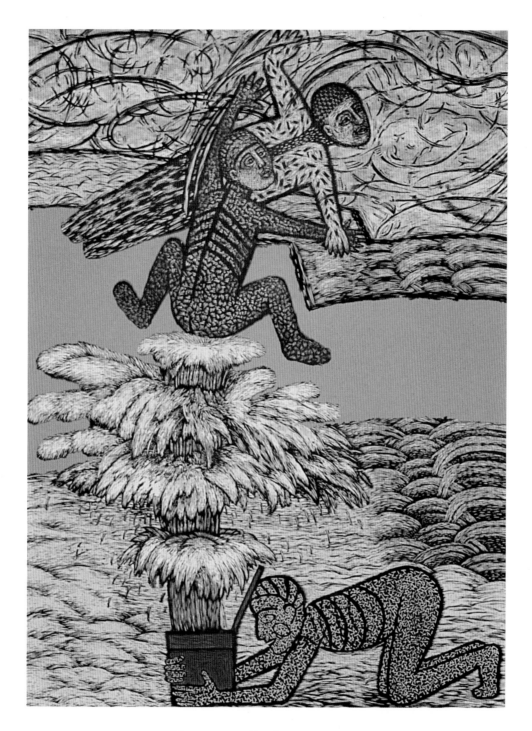

MARGARET H. PRENTICE

Another Flying Dream

40" × 30" (102 cm × 76 cm)
Oil-based ink, handmade paper
(cotton), shaped exterior deckle,
pigmented pulp
Technique: Relief woodcut

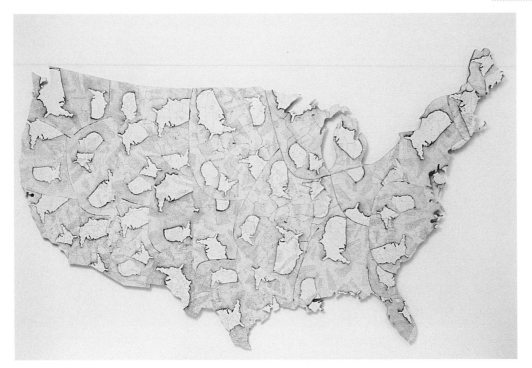

Cracktal Composition II

60" × 96" (152 cm × 244 cm)
Printed on Formica, laminated to wood
Technique: Lithograph, collage

Spahr made this collaged map in the year the artist became a United States citizen. Part of the text fragments scattered over the reversed United States map are taken from the Pledge of Allegiance.

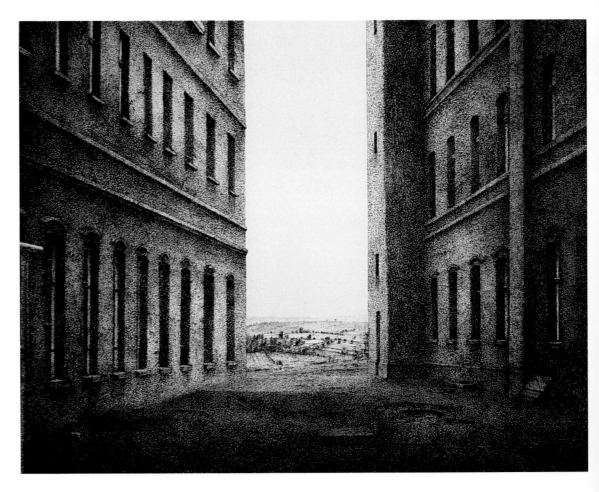

JAN SZMATLOCH

Landscape

30" × 23" (76 cm × 58 cm)
Charbonnel etching ink, Hahnemühle paper

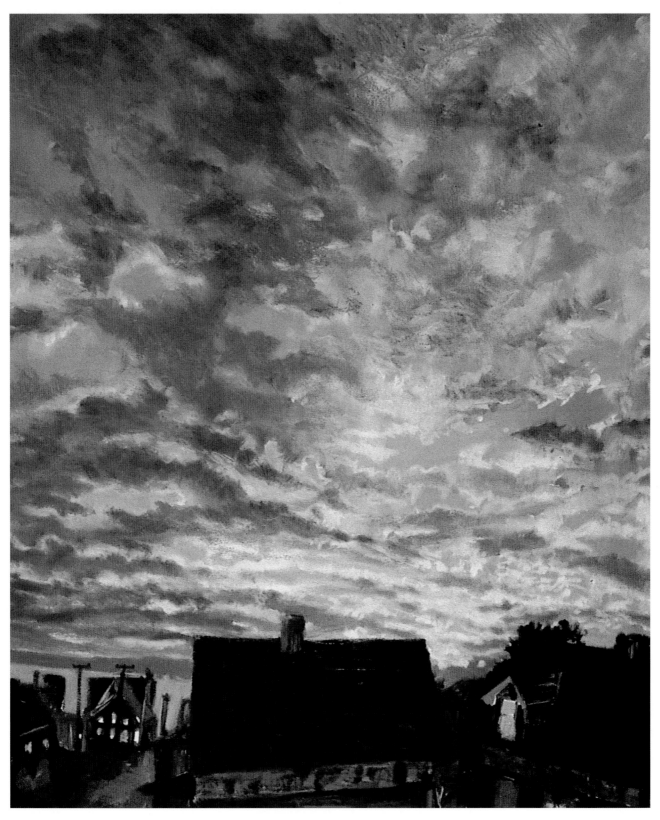

Morning Lights

30" × 24" (76 cm × 61 cm)
Oil-based ink, Rives BFK paper
Technique: Monotype

GLEN ROGERS PERROTTO

Ethereal Vessel

41" × 29.5" (104 cm × 75 cm)
Oil-based ink, Arches Cover paper
Technique: Drypoint, monoprint

The use of ancient symbols from the Neolithic era becomes a universal visual language for the divine feminine.

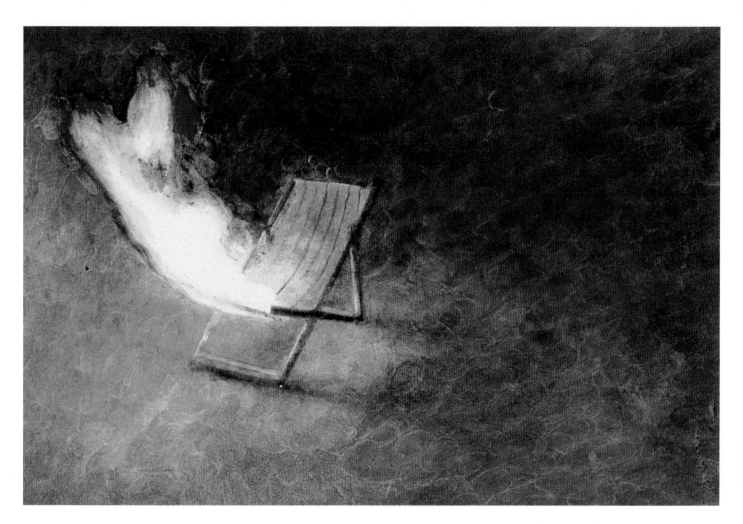

Burning Beach Chair

11" × 17" (28 cm × 43 cm)
Etching ink, transparent base (china clay), Arches 88 paper
Technique: Multiple-drop monotype, printed dry off a Mylar plate

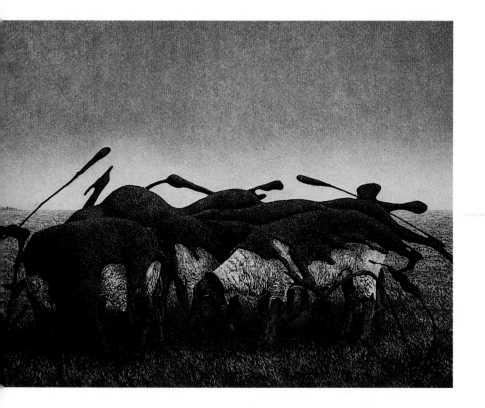

WILLIAM J. KITCHENS

Desperate Sheep

12" × 9" (30 cm × 23 cm)
Graphic Chemical ink (#514), Lana Gravure paper, copper plate
Technique: Intaglio, rosin and airbrush aquatint, soft ground/tracing paper, hard ground

The subject matter of this print refers to 1950s B-grade science fiction movies.

Watermark Series, Balancing Spirits

60" × 108" (152 cm × 274 cm)
Oil-based ink, Rives BFK paper, hand-made paper
Technique: Woodcut relief, chine collé, anagram copy transfer

This image is charged with symbols of land and fertility and tells a mytho-logical story of "mining ponies" being born in the bowels of the earth.

DAVID MOHALLATEE

Monolith

24" × 18" (61 cm × 46 cm)
Oil-based ink, Rives BFK paper (white)
Intaglio (etching, aquatint)

This print incorporates copper etch-ing, rosin aquatint, and hand-applied roulette work on the background; it's architecturally influenced, based on bridge and dam supports.

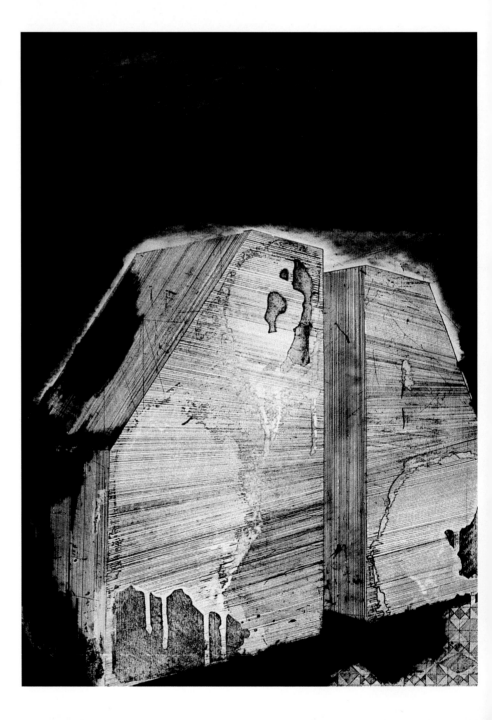

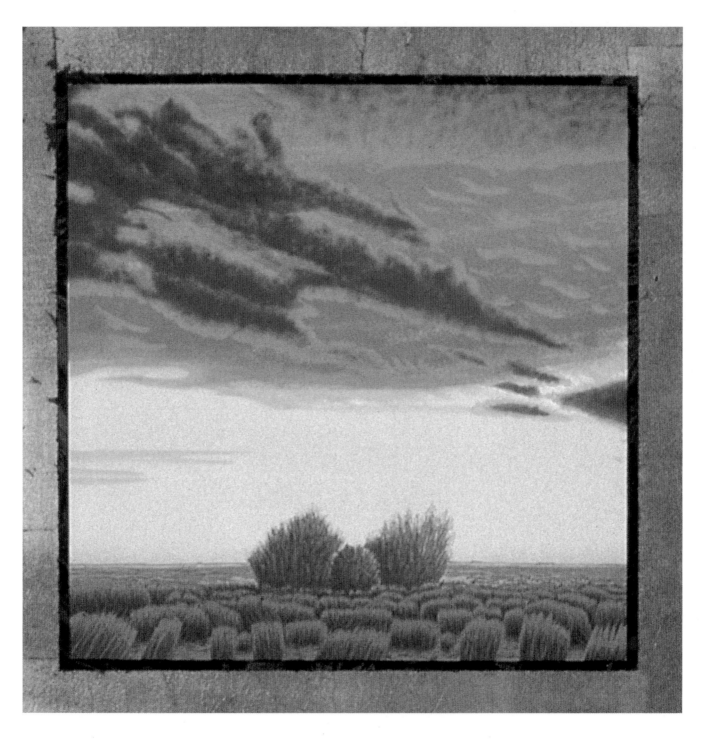

JOHN BEERMAN

Two Bushes at Twilight

27" × 7" (69 cm × 18 cm)
Somerset paper (soft white)
Technique: Lithography with gold leaf

BEST OF PRINTMAKING / 63

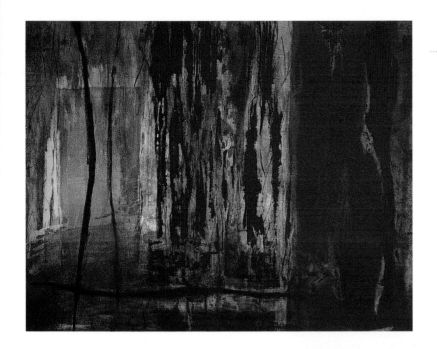

JO GANTER

Three Parts Red

38" × 43.5" (97 cm × 110 cm)
Velin Arches paper
Technique: Intaglio on steel

OROSZ CSABA

Analogue Studies VI

19.5" × 15.5" (50 cm × 39 cm)
Oil-based inks, French etching paper
Technique: Etching, drypoint, linocut

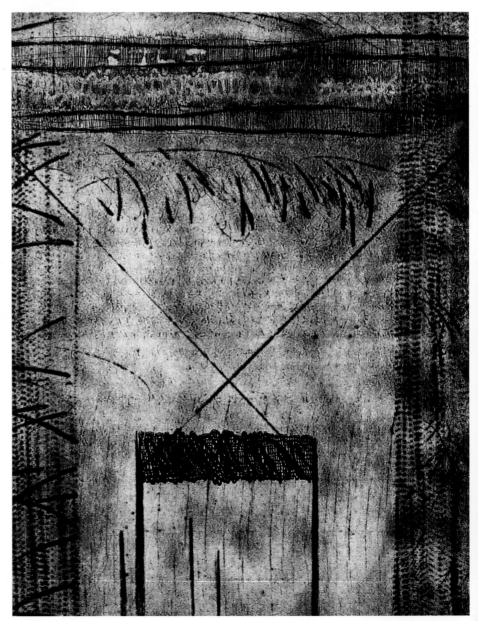

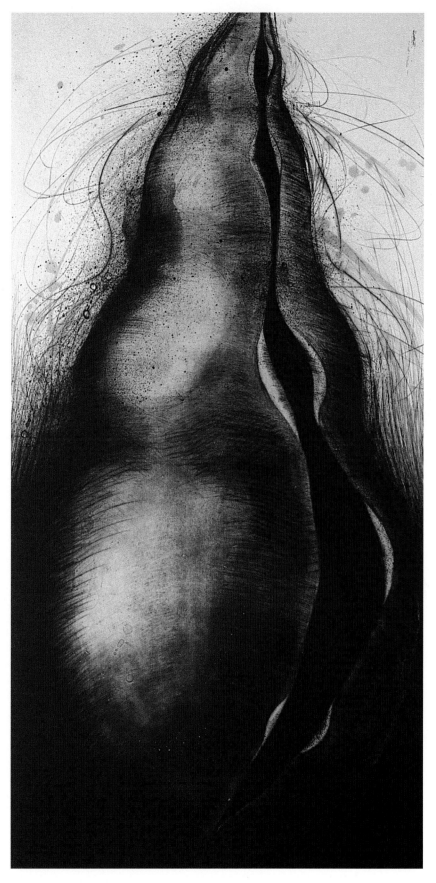

TANJA SOFTIC

Peeling

36" × 18" (91 cm × 46 cm)
Daniel Smith etching ink, Hahnemühle
Copperplate paper
Technique: Intaglio

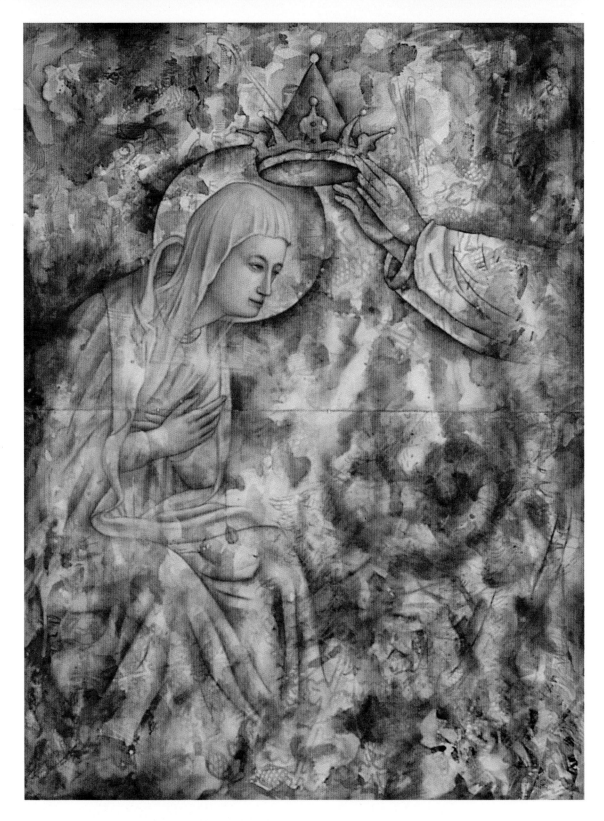

MATTHEW SUGARMAN

Women Are Smarter

60" × 44" (152 cm × 112 cm)
Water-based screen-printing ink, pastels, charcoal, Rives BFK paper (gray)
Technique: Screenprint, painting, drawing

The symbolism of God crowning Mary is appropriated to represent the idea of all women being revered for qualities specific to them.

MELVYN L. PETTERSON

Hainton Track Snow

22" × 16" (56 cm × 41 cm)
Oil-based ink, Somerset paper (white, 300 gsm)
Technique: Intaglio, etching (17 bites)

"This area normally looks like a tip (a dump)," Petterson says. "It's fantastic what snow can do to improve things."

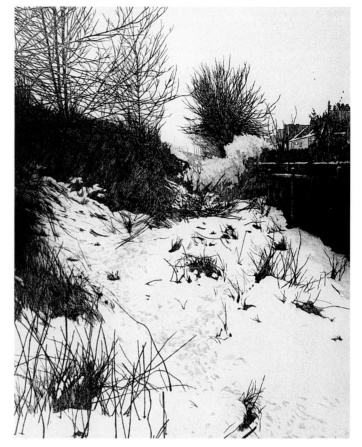

PETER FORD

Cypher II

8.5" × 9" (22 cm × 23 cm)
Oil-based etching and litho ink, Somerset Satin paper (300 gsm, 100% cotton, acid-free, white)
Technique: Print from wood inked on both intaglio and relief surfaces

In this print, the paper is embossed where the wood has been pierced; repeated printing from the matrix produces overlays of color.

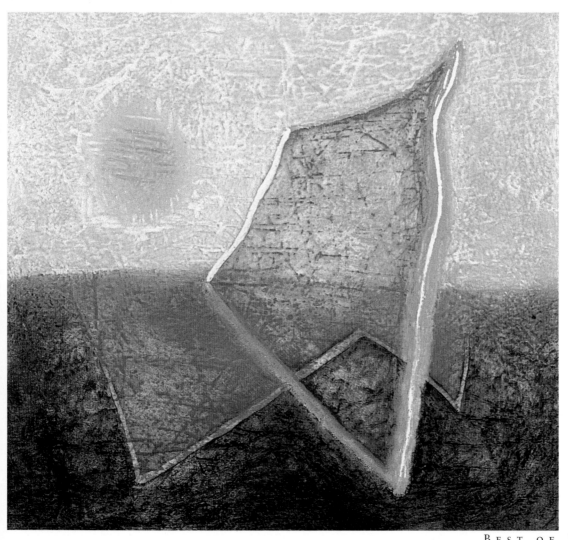

LINDA LYKE

Basket Icon I

27" × 38" (69 cm × 97 cm)
Oil-based ink, oil pastel, Arches paper
Technique: Monotype, mixed media,
acetate ghost image

*This piece conveys a binary composi-
tion which brings into question the
idea of image and border, printmak-
ing and painting, positive and negative.*

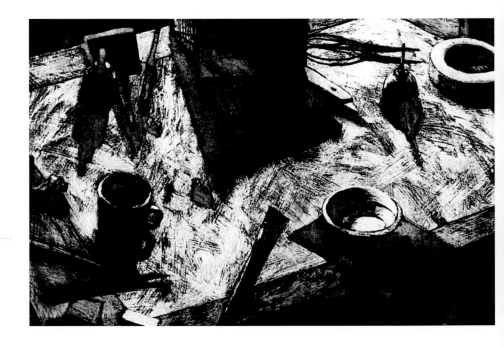

STEPHEN R. SIMONS

Drawing Board

22" × 33" (56 cm × 84 cm)
Handmade ink, Rives BFK paper
Technique: Etching

CONSTANCE JACOBSON

Animal Vegetable Series #3

9" × 9" (23 cm × 23 cm)
Oil-based inks, Rives BFK paper
Technique: Soft ground etching (two plates), drypoint

These tender and sad images reflect the tenuous position of animals in the environment, as nature is further isolated and destroyed by humans.

Conversacion Sin Fin ("Endless Conversation")

30" × 44" (76 cm × 112 cm)
Pure pigments, Rives BFK paper
Technique: Fresco on paper

Dry pigments are pressed onto the paper through the use of a Plexiglas plate and the pressure of a print-making press.

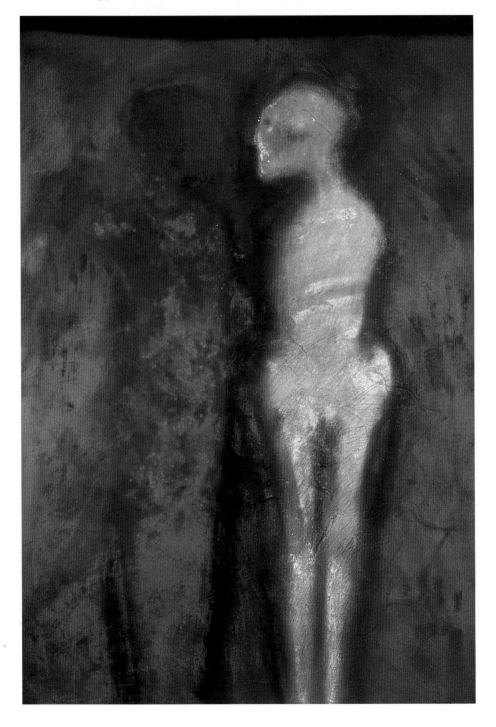

SHEILA ROSS

Abstract Landscape #1

52" × 25" (132 cm × 64 cm)
Oil-based etching and litho ink, hand-made Japanese paper
Technique: Multiple drop monotype

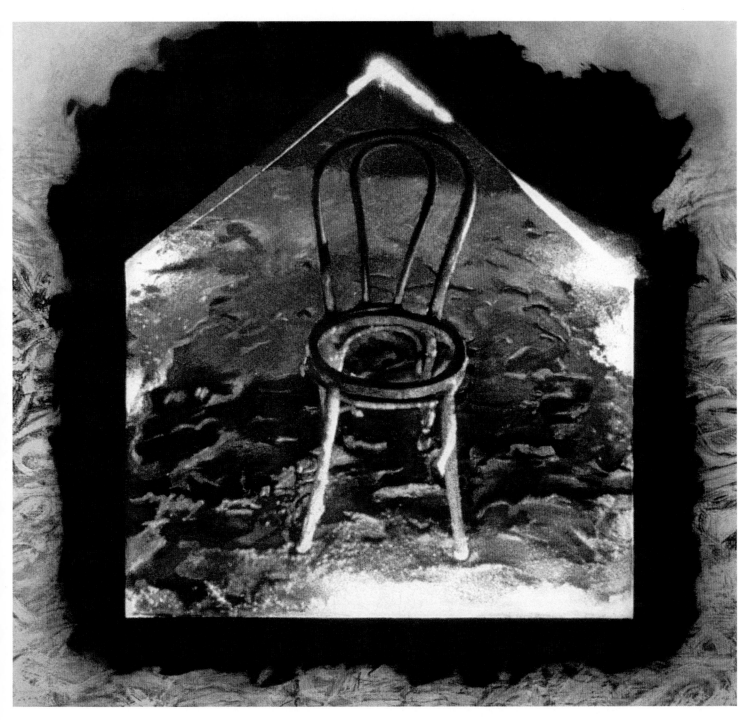

EDWARD BERNSTEIN

Cold Fire #2

18" × 19" (46 cm × 48 cm)
Fabriano Magnani Pescia paper, two
zinc plates
Technique: Photo-etching, aquatint and
white ground on two plates

*A cold light from a warm fire—this
image is based on an actual built
structure that was set on fire.*

CARMON COLANGELO

Ducking Stool

22" × 30" (56 cm × 76 cm)
Litho ink, Rives BFK paper
Technique: Lithography (stone
lithography with four color runs)

A ducking stool is a medieval tortur-
ing device to detect witches; here the
image is used as a metaphor for those
victimized by ignorance in our
society.

PASTERNAK

Profils Sous Angle II

25.5" × 19.5" (65 cm × 50 cm)
Oil-based ink, Somerset paper
Technique: Mezzotint

MARY MARGARET SWEENEY

When No One Is There

24" × 18" (61 cm × 46 cm)
Graphic Chemical etching ink (vine
black), Rives BFK paper (white)
Technique: Etching

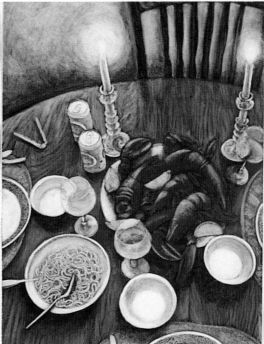
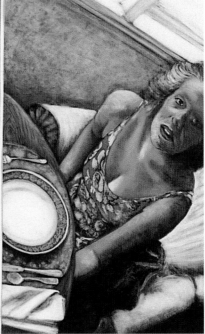

Barbara Elam

Lobster Eaters

44" × 83" (112 cm × 211 cm)
Ink, Rives BFK heavyweight paper
Technique: Relief, multiple plate mono-
type

*"Lobster Eaters" is one of a series,
"Boston Impressions," created during
Elam's 1989–90 fellowship at the
Bunting Institute.*

Kathryn J. Reeves

Schoolhouse

24" × 18" (61 cm × 46 cm)
Oil-based ink, Lana Gravure paper,
zinc plate, mat board
Technique: Intaglio and color relief

*The representation of a small chalk-
board or slate in "Schoolhouse"
confronts us with the reality of what
society teaches children.*

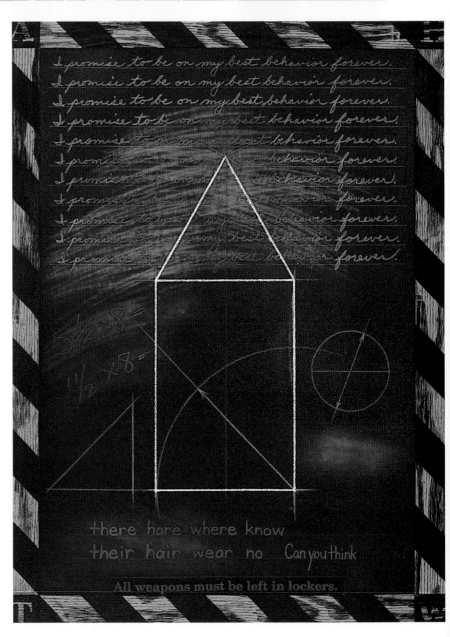

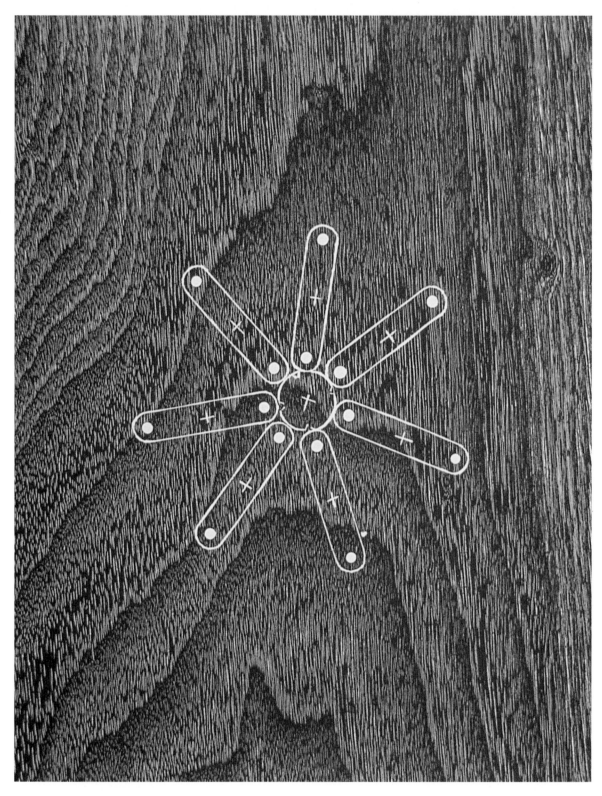

ANN CONNER

Wilderness VI

15" × 13" (38 cm × 33 cm)
Oil-based ink, Saunders Waterford paper
Technique: Relief print

Woodgrain plays a prominent role in this narrative suite of eight prints. Printed from a single block of walnut, plastic Lego blocks are positioned on the wood grain providing an oblique reference to nature.

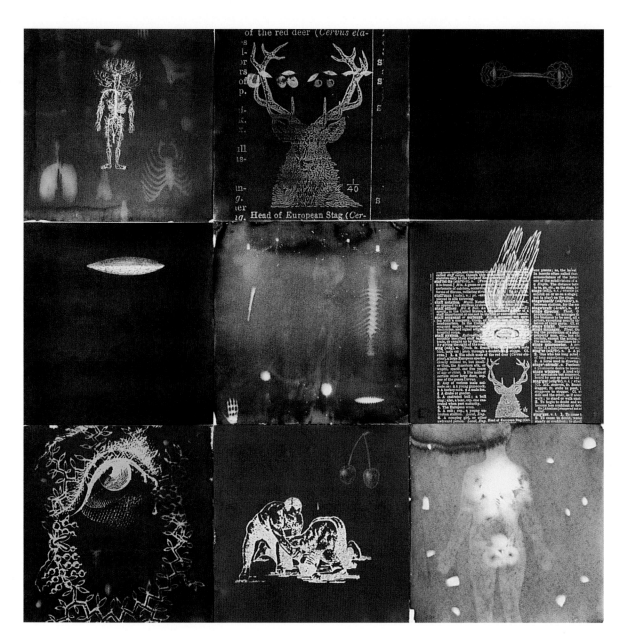

PAM LONGOBARDI

Storia della Natura

36" × 36" (91 cm × 91 cm)
Water-based gouache, rice paper, Italian
papers
Technique: Intaglio, cyanotype and
Vandyke brown prints, chine collé,
gouache

*The cyanotype and Vandyke brown
prints offer a phenomenological
record of Italian sun and sudden gusts
of wind, blowing the found objects
and Kodaliths. "Storia della Natura"
translates as "natural history"—or are
they the "stories of nature"?*

SUZANNE McCLELLAND

Untitled

23" × 18" (58 cm × 46 cm)
Cedar Gasen (mulberry), plastic vellum, nacre (white)
Technique: Lithography, chine collé

BARBARA MILMAN

Memorial #2

17" × 12" (43 cm × 30 cm)
Water-based Graphic Chemical relief ink, Rives Heavyweight paper
Technique: Linocut

This image is based on memorial stones in the Jewish cemetery that was in the Warsaw ghetto.

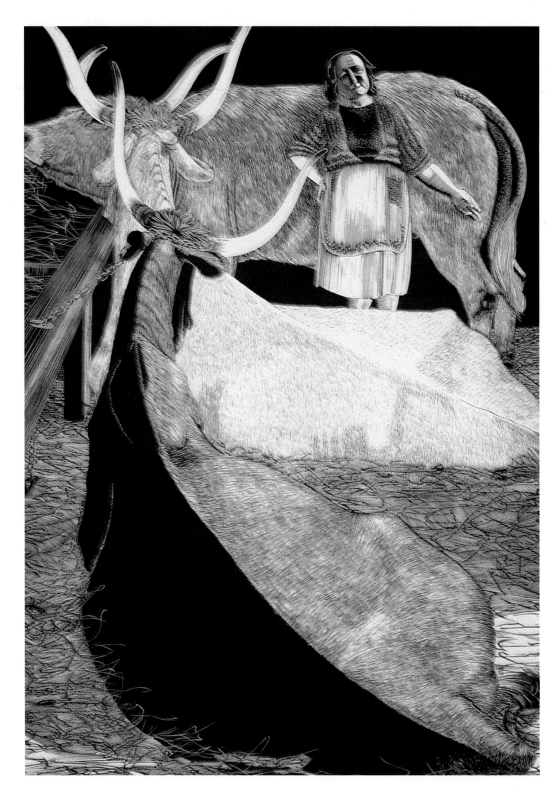

SARAH VAN NIEKERK

Signora Fernando

8" × 6" (20 cm × 15 cm)
Boxwood, oil-based ink, Zerkall paper
(Monio Mane acid-free, #7625, 145
gsm)
Technique: Wood engraving relief-
printed damp

*The rhythmic lines of the Maremma
cattle interact with the sweep of the
horns and the pride of the broker.*

Equilibrio Precario ("Precarious Balance")

30" × 44" (76 cm × 112 cm)
Pure pigments, Rives BFK paper
Technique: Fresco on paper

Dry pigments are pressed onto the paper through the use of a Plexiglas plate and the pressure of a printmaking press.

HUGH J. MERRILL

Facts of Fictions 4

36" × 24" (91 cm × 61 cm)
Rives BFK paper (gray)
Technique: Sequential etching

"Facts of Fictions" is a series of sequential etchings. Merrill's concerns were the creation of a continuous narrative, the possibility of an infinite series of images limited by the finite quality of the etching plate, and the representation of contemporary reality as trauma, conflict, and evolving turmoil.

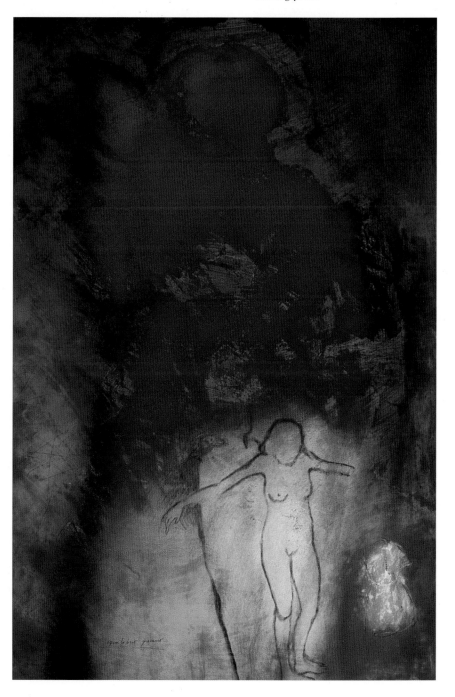

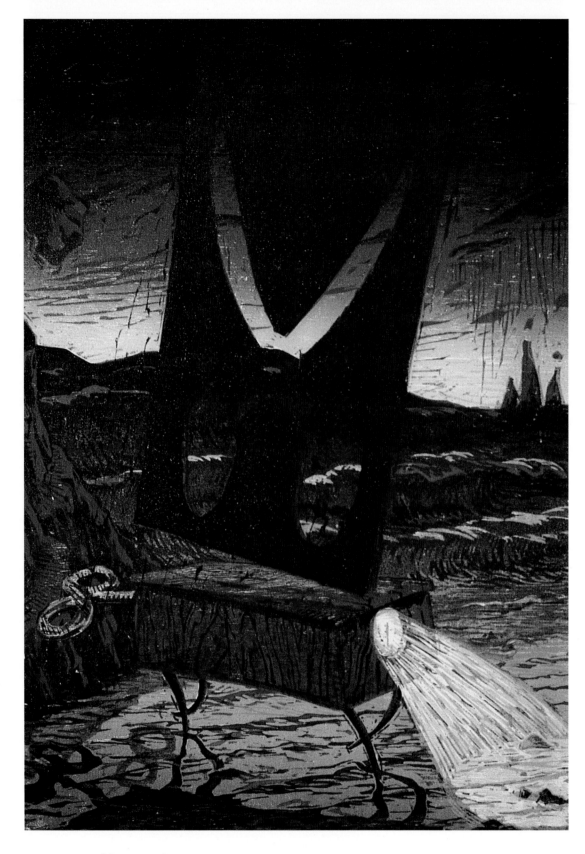

MAGNUS IRVIN

Stranger on the Shore

24" × 17.5" (61 cm × 44 cm)
Oil-based ink, Lana paper
Technique: Woodcut

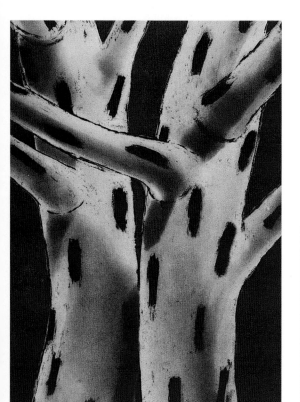

NONA HERSHEY

Arborescent Sagas #8

10" × 7.5" (25 cm × 19 cm)
Charbonnel ink, Kitikata paper,
Somerset paper (white), two copper
plates
Technique: Intaglio, chine collé

*"Arborescent Sagas #8" is from a
series of eight images; the anthropo-
morphic character of the trees refers
to the shared way in which the artist
imagines organic forms converse.*

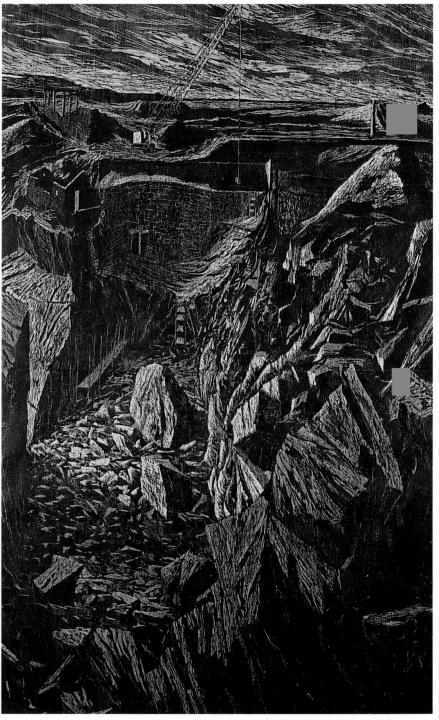

EMMA STIBBON

Trewellard Zawn

75" × 48" (191 cm × 122 cm)
Oil-based ink on Japanese paper
Technique: Color woodcut on ply-
wood, printed by hand

*Stibbon was interested in the way this
difficult Cornish landscape had been
harnessed to mine tin in the 19th cen-
tury; she was attracted by the drama
of the rocks and cliffs.*

ÁRPÁD MIKLÓS

Prometheus

16" × 20" (41 cm × 51 cm)
Typographic ink, Fabriano Ingres paper
Technique: Linocut

JAMES ENGELBART

Lucilius' 1st Satire

17" × 14" (43 cm × 36 cm)
Etching ink, zinc plate
Technique: Etching, scraping, chine
collé, à la poupée inking

*This print is an effort to make Latin
live again using dog poetry (much
more interesting than Cicero).*

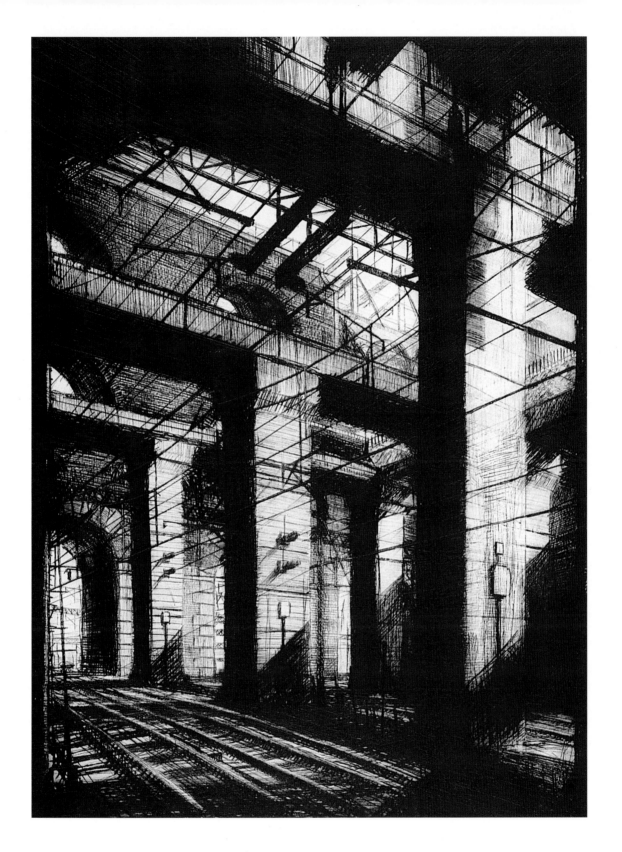

JOHN HOWARD

Railway Study No. 2

24" × 18" (61 cm × 46 cm)
Etching ink, Lana 1590 Edition paper
Technique: Drypoint

This image is based on the architectural imagery of New Street Station, Birmingham, England.

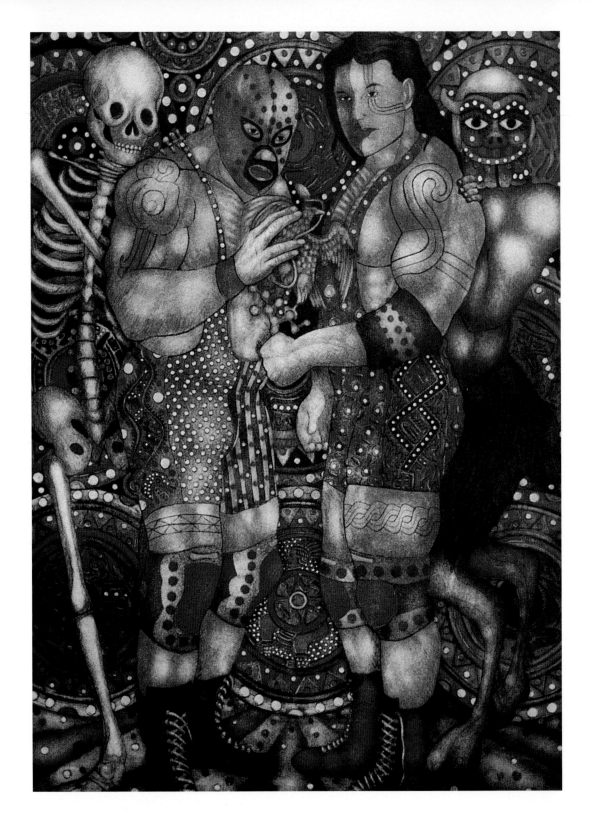

CHARLES BARTH

New Warriors

24" × 18" (61 cm × 46 cm)
Oil-based ink, Rives BFK paper
Technique: Intaglio, line etching,
aquatint

*Lucha Libre wrestling is a popular
event in Mexico. Children look
towards the wrestlers as heroes and
role models, and the colorful event
becomes a family affair.*

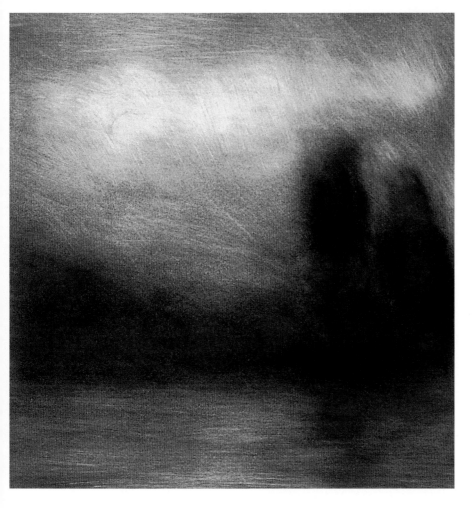

The Artificial Infinite #1

19" × 19" (48 cm × 48 cm)
Oil-based ink, Rives BFK paper (white)
Technique: Monotype, drypoint

Pierce chose the print medium to produce an installation of twenty-eight atmospheric images; her work reflects the 17th-century concept of the sublime, embodying a sense of longing, vibrating with memory, and evoking what may never be again.

KIM HUYNH
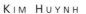

White Myth, Wing of an Etymon

72" × 36" (183 cm × 91 cm)
Oil-based ink, Rives BFK paper
Technique: Etching, chine collé, stencil

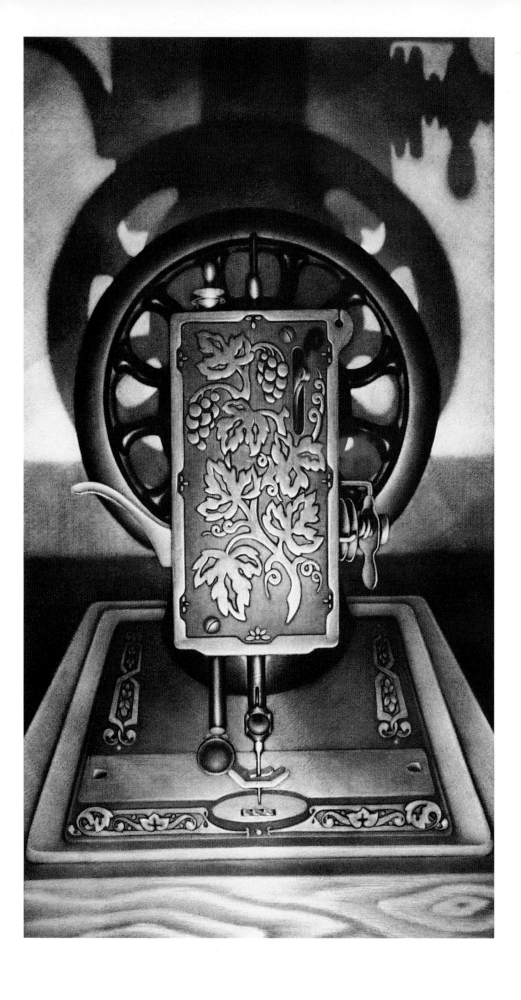

Singer II

14.5" × 8" (37 cm × 20 cm)
Ink (cool black), German etching paper
Technique: Mezzotint

The illusion of depth in "Singer II" is created by contrasting the reflected light on tooled metal against a matte background; the effect was achieved by burnishing a 150-gauge roulette ground in the central rectangle and scraping the surrounding ground, which was rocked with a 40-gauge rocker on very hard copper.

SCOTT STEPHENS

Untitled (487)

35" × 42" (89 cm × 107 cm)
Oil-based ink, Rives BFK paper
Technique: Collagraph (relief and
intaglio on Plexiglas plate)

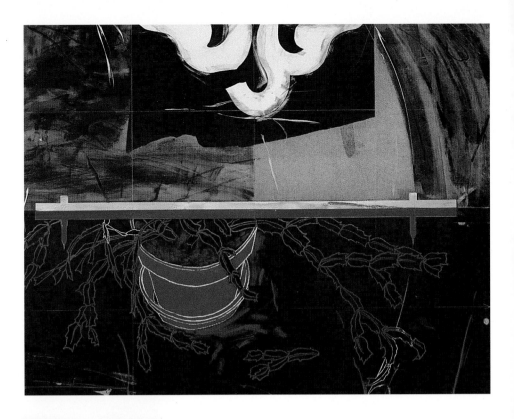

ARIEL VIK

Phantom Limb

22" × 30" (56 cm x 76 cm)
Oil-based ink, Arches Cover paper,
00# varnish, paper stencils
Technique: Mixed-media monoprint:
traditional monoprint off Plexiglas,
woodblock stencils, photo- and
computer-generated artwork, photo-
copy transfer, relief

*Bonding, dependency, separation
anxiety, instinctual protectiveness,
nurturing, and identity displacement
are parallel psychological states
experienced by both the child and his
or her adult parent. Recent works
have revealed a complex dynamic
between these seemingly natural
parental sensibilities.*

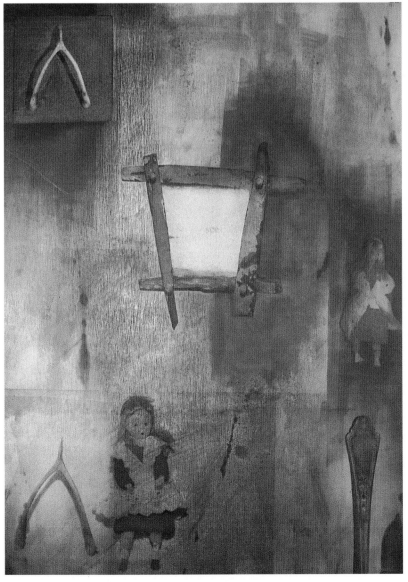

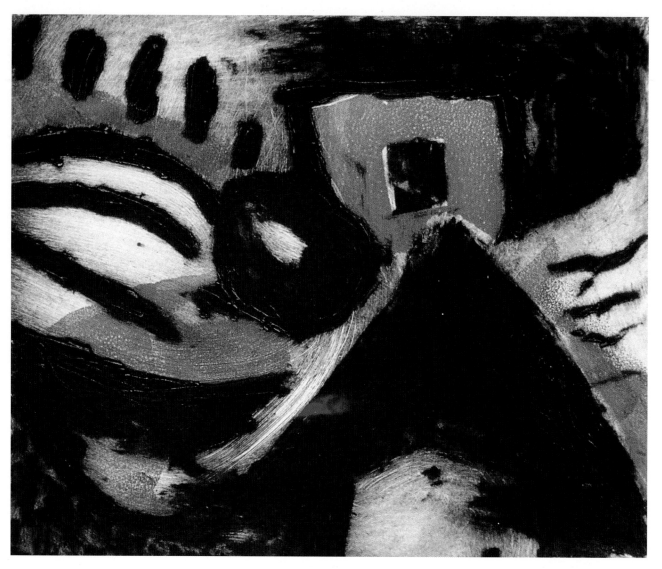

Empty House

12" × 15" (30 cm × 38 cm)
Oil-based printer's ink, Rives BFK
paper (white)
Technique: Carborundum, stencil

M A R T I N G A R C I A - R I V E R A

Encantador de Sierpes

48" × 36" (122 cm × 91 cm)
Oil-based ink (yellow, red, black), three
wood planks
Technique: Relief, woodcut print hand-
printed by the artist

*This image is a metaphor about magic
syncretism in Caribbean culture.*

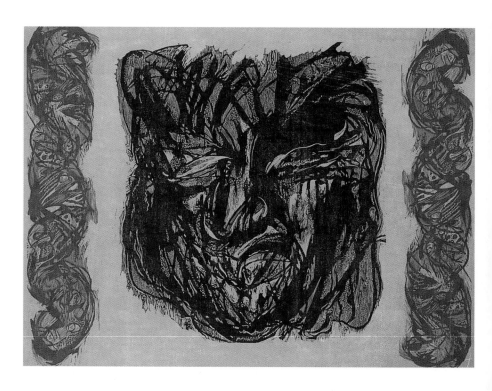

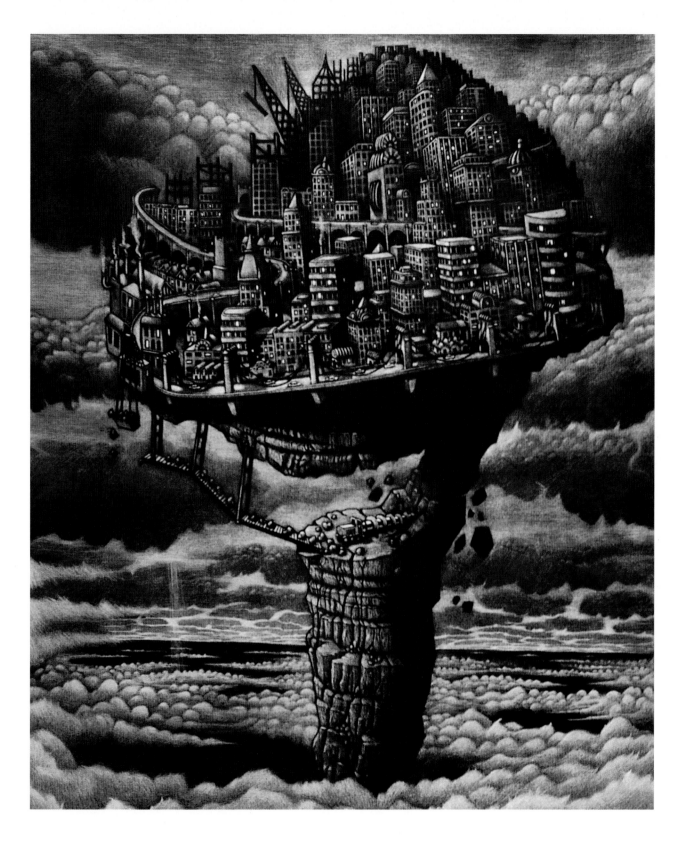

MARTIN LANGFORD

..

Capital Growth

20" × 17" (51 cm × 43 cm)
Graphic Chemical ink (black),
Somerset Satin paper
Technique: Intaglio, mezzotint on cop-
per plate, ground prepared with 65-
gauge rocker

*The depletion of natural resources for
man's gain will lead to his downfall.*

BEST OF PRINTMAKING / **89**

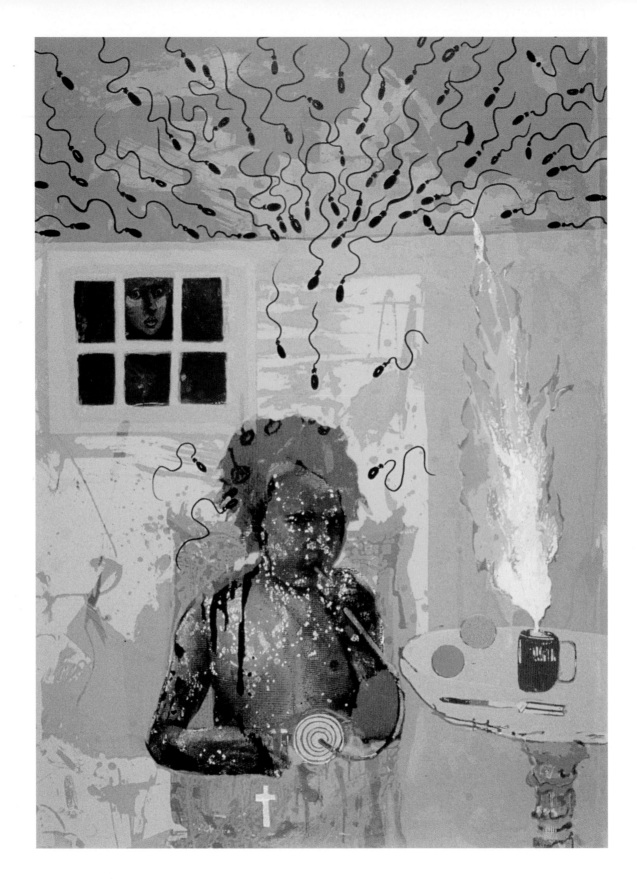

CRAIG DONGOSKI

Nocturnal Visitor for Secret Vices

27" × 20" (69 cm × 51 cm)
Oil-based ink, pastels, aquaprint paper
Technique: Mixed-technique screen-
print

*Part of a series loosely based on the
Tarot, this piece is inspired by the
"Tower of Destruction" card.*

ALBERT DANIELS

Viktor

100" × 75" (254 cm × 191 cm)

Oil-based ink, Hahnemühle paper (300 gsm)

Technique: Etching, aquatint, woodcut, printed gold powder

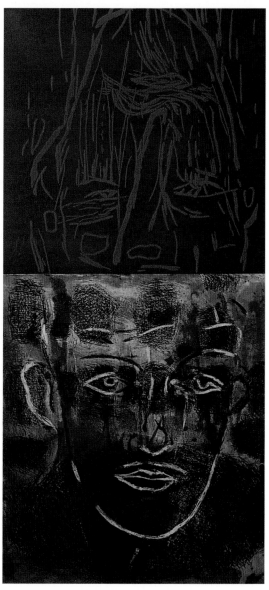

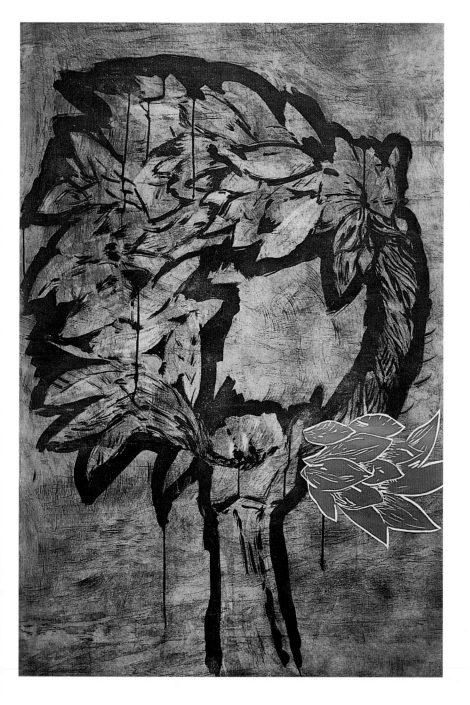

ALBERT DANIELS

Twins

100" × 50" (254 cm × 127 cm)

Oil-based ink, Hahnemühle (300 gsm)

Technique: Etching, aquatint, woodcut, printed gold powder

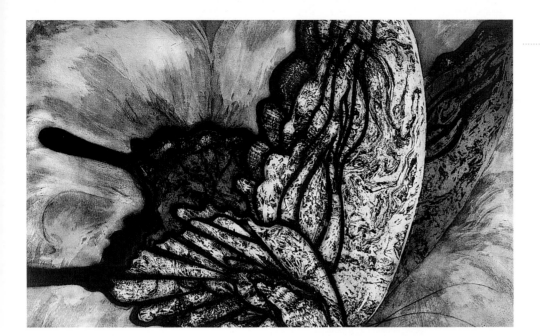

ROSE K. McCAUGHEY

Stage of Splendor

24" × 38" (61 cm × 97 cm)
Oil-based Etching ink (black), Rives BFK paper (white, 270 gsm)
Technique: Intaglio etching, aquatint, marbling, sugar lift

ROBIN McCLOSKEY

Travel

26" × 21" (66 cm × 53 cm)
Oil-based ink, Lana Gravure paper
Technique: Photo-etching, soft ground, aquatint, monotype

Creating film for photo-etching on the computer allows for the seamless melding of images from various sources; the resulting photo-montage has a "factual" character despite its often surreal nature.

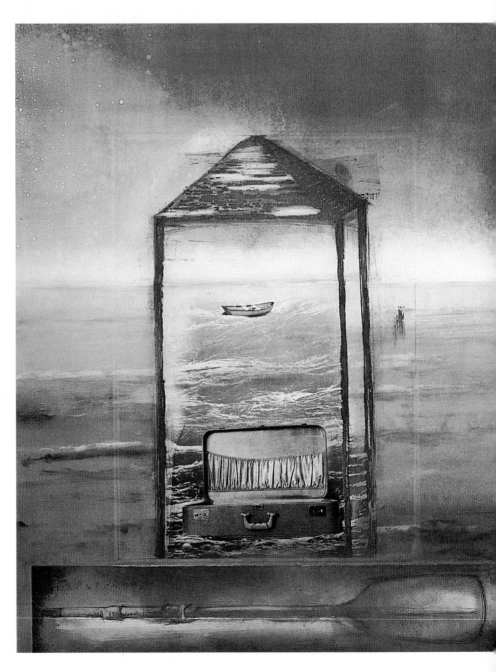

MICHAEL SOUTHERN

Cloudy Water, Tryon Creek

13" × 16" (33 cm × 41 cm)
Gamblin oil-based ink, Lana Gravure
paper
Technique: Intaglio

BEST OF PRINTMAKING / 93

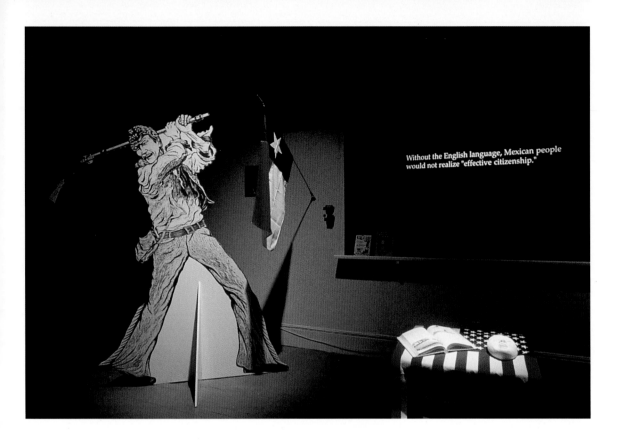

Without the English language, Mexican people would not realize "effective citizenship."

EMMANUEL C. MONTOYA

Reclaiming Lost Tongues (detail showing Davy Crockett)

72" tall (183 cm)
Oil-based ink, Japanese paper
Technique: Woodcut; print is cut out and mounted on free-standing FomeCore

The Crockett figure is a detail from this mixed-media installation that talks about the false notion of freedom Chicanos experienced when they were castigated for speaking Spanish in school.

GLEN ALPS

A Pilchuck Summer

18" × 24" (46 cm × 61 cm)
Oil-based ink, Arches paper
Technique: Intaglio, using glass plates and vitreograph

ROBIN McCLOSKEY

Treehouse 2

40" × 30" (102 cm × 76 cm)
Oil-based ink, Rives BFK paper
Technique: Photo-etching, etching,
aquatint, monotype, hand-coloring,
collage

*This treehouse, a precarious structure,
suggests something of the uncertainty
which lies ahead in the child's life and
which gives rise to superstitious
beliefs (symbolized by the playing
cards).*

An Observation

45" × 24" (114 cm × 61 cm)
Mueller inks, Somerset Satin paper
Technique: Photo-mechanical lithography (four panels sewn together, five plates)

A social commentary based on a Scandinavian fairy tale, this image comments on relationships.

Written in the Body

22.5" × 26" (57 cm × 66 cm)
Rag coat paper
Technique: Four-color, digitally gener-
ated, hand-printed lithograph

JOE PRICE

Egg Series I: Red Vise

4" × 4" (10 cm × 10 cm)
Oil-based ink on museum board
Technique: 51 color serigraph

RAND BORDEN

All's Fair

20" × 36" (51 cm × 91 cm)
Water-based Naz-Dar ink, aquaprint
paper
Technique: Screenprint

*This print is based on the saying
"All's fair in love and war"; it was
created for an international print
exchange.*

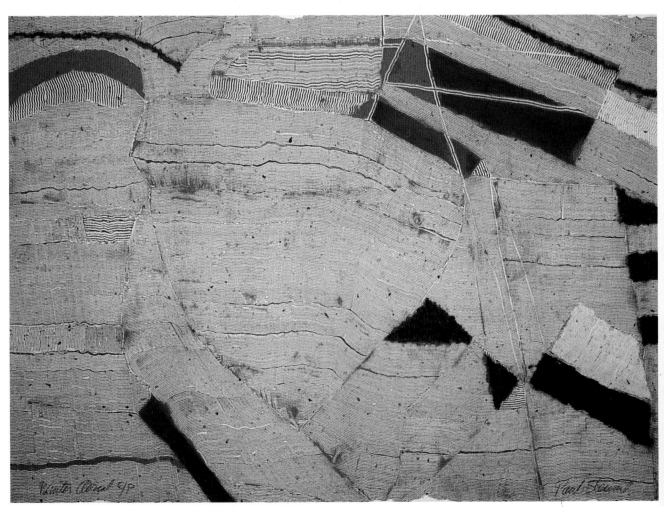

PAUL L. STEWART

Winter Aerial

30" × 40" (76 cm × 102 cm)
Oil-based ink, handmade paper
Technique: High-relief intaglio

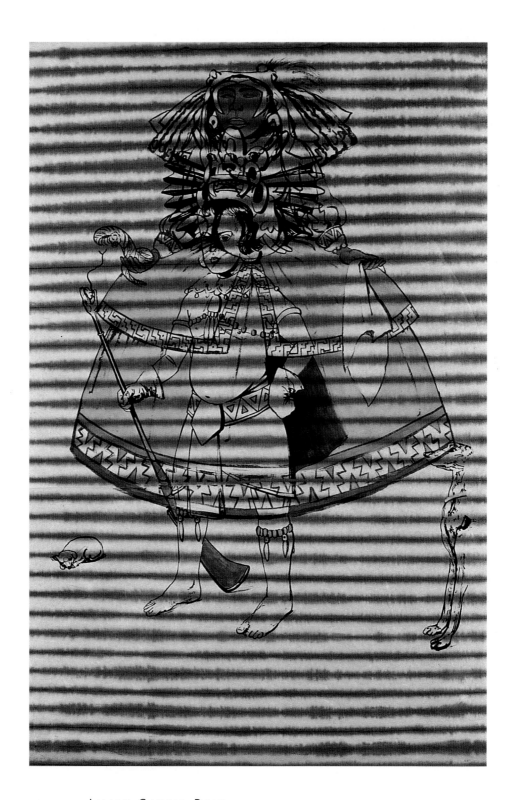

LILIAN GARCIA-ROIG

Translating Between the Lines

37" × 25.5" (94 cm × 65 cm)
Litho ink, predyed paper
Technique: Photo-lithography, mono-
printing

*Garcia-Roig wanted to combine
images of Meso-American and
Western European art ideals in a
manner that would enhance, not
negate, each image's presence.*

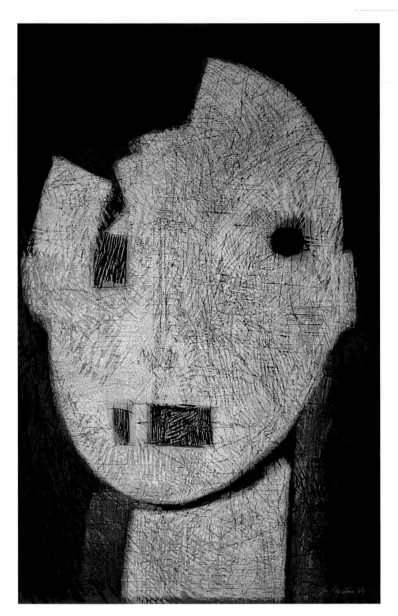

Head No. 2

34" × 28" (86 cm × 71 cm)
Oil-based ink, Japanese Moriki paper
Technique: Woodcut

*This head is a study for a sculpture;
the image addresses form and surface.*

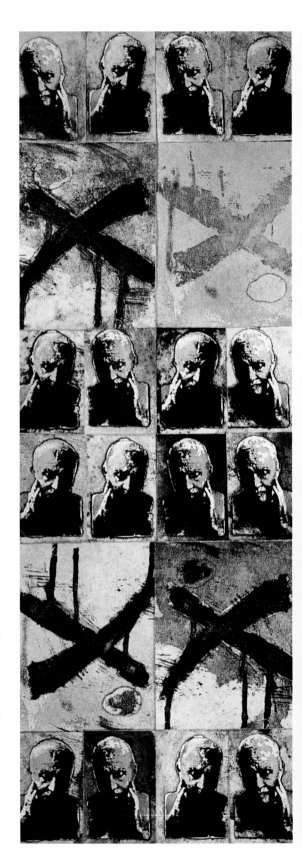

NESTOR MILLAN

Epistle

30.5" × 11" (77 cm × 28 cm)
Oil-based etching ink, water-based
metallic pigments, Rives BFK paper
Technique: Collaged photo-etching and
aquatint on hand-colored paper

*This portrait of the artist's late father
deals with the "silences" of lack of
communication between father and
son due to generational differences.*

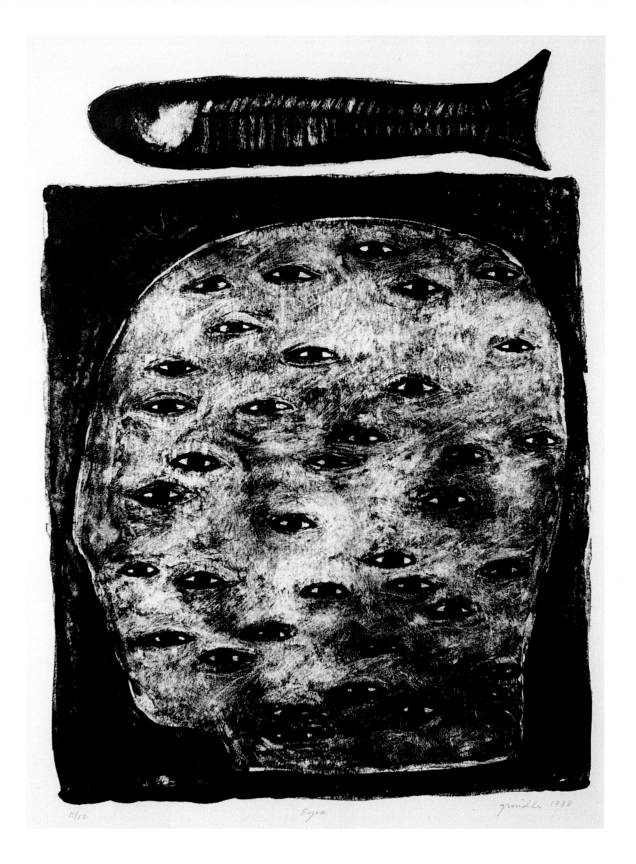

ALLEN GRINDLE

Eyes

16.5" × 12.5" (42 cm × 32 cm)
Oil-based ink, Rives BFK paper
Technique: Lithography

Grindle usually prefers black and white because of the immediacy not only in the process but in the final impact.

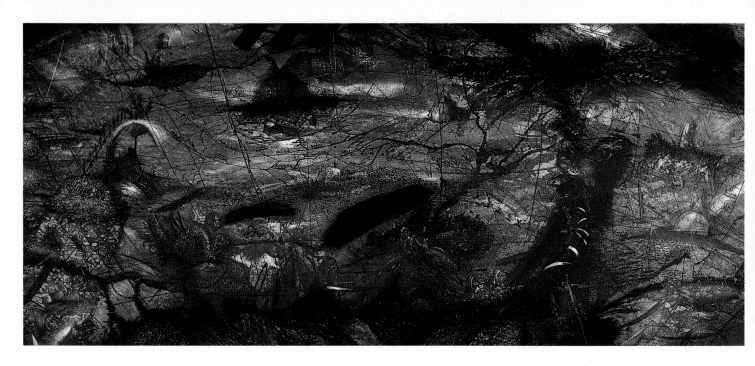

NATALIA MIRONENKO

Omen-Arena

23.5" × 53" (60 cm × 135 cm)
Etching ink, Velin Arches paper
Technique: Color etching

ALISON HILDRETH

Timepiece

12" × 31" (30 cm × 79 cm)
Oil-based ink
Technique: Etching, aquatint, engraving, drypoint

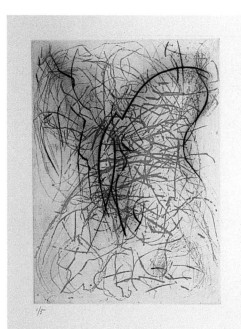
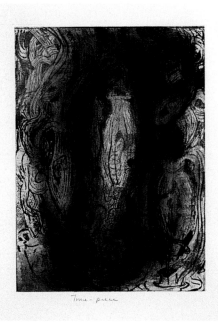
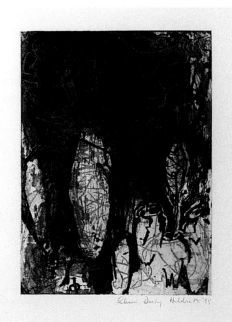

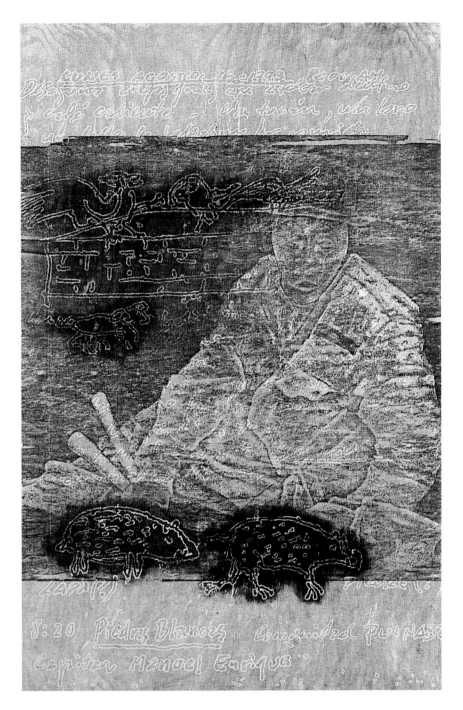

RIMER CARDILLO

Gold Sticks and Cachicamo Island

84" × 60" (213 cm × 152 cm)
Oil-based inks, canvas (natural-color
cotton duck, 12 oz.)
Technique: Woodcut

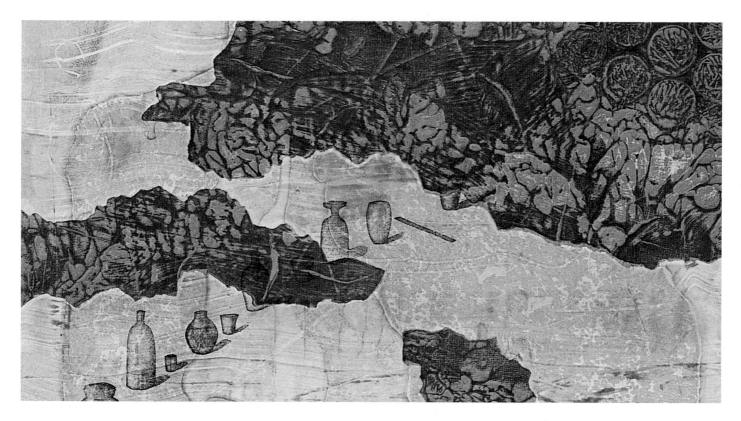

LAWRENCE YUN

Discovery

10" × 17" (25 cm × 43 cm)
Oil-based ink, Kitakata paper, Rives
BFK paper (white)
Technique: Etching, chine collé, colla-
graph, monotype

*This image is part of an experiment in
multiple drops that involves different
techniques each time.*

JEANE K. MCGRAIL

Anishinabe Mokuan Series

3" × 4" (8 cm × 10 cm) to 6" × 6" (15
cm × 15 cm)
Oil-based ink, Arches Cover paper,
artificial sinew, bones, clay beads
Technique: Intaglio with sinew

*This series culminates in the artist's
Ojibwe heritage, accessing genetic
memory through the limbic brain
when connected to meditating in
forests and by wilderness lakes; the
meshed linear field of space holds the
colors of the forest, dimensionalized
by multiple impressions.*

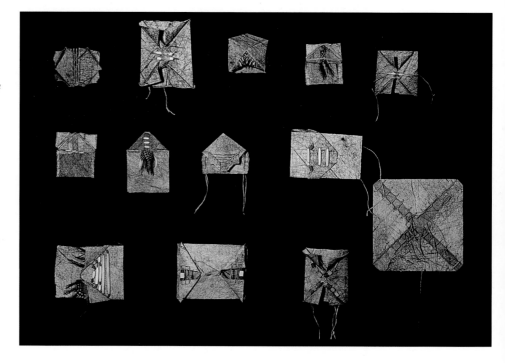

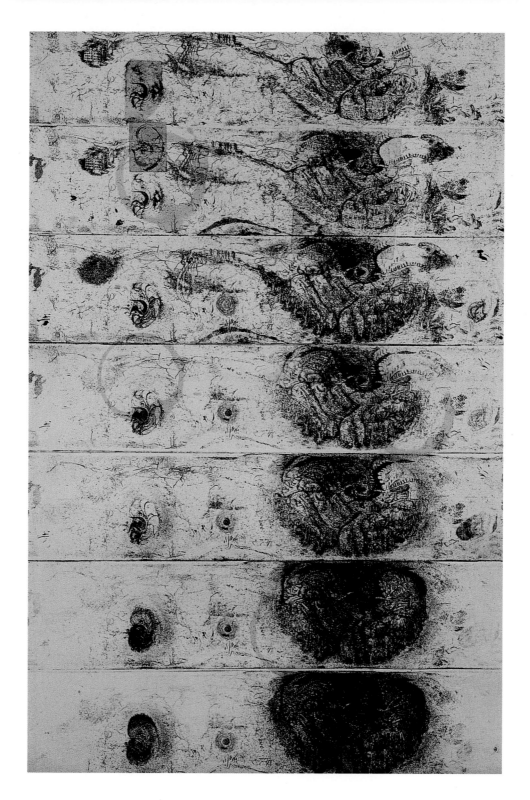

Amphitheater—Volvulus

29" × 21.5" (74 cm × 55 cm)
Oil-based intaglio ink, water-based
screenprinting ink, Velin Arches paper
(400 gsm)
Technique: Intaglio on copper,
silkscreen, collage, water-colored by
hand

*"Amphitheater—Volvulus" is part of
the "Card-Index" collection, showing
the history of the place pictured.*

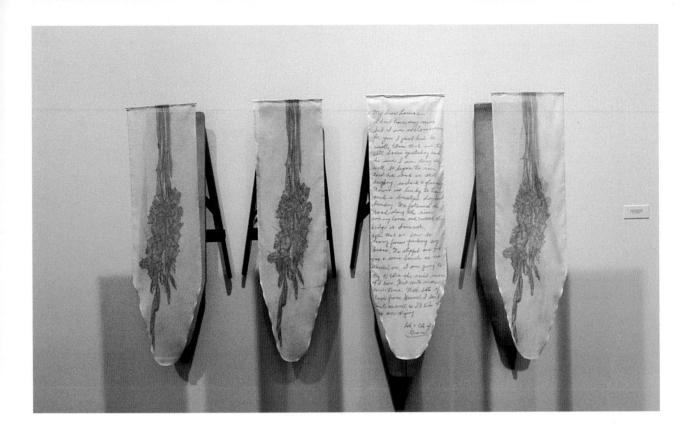

LOUISE KAMES

Elegy for Ellen

48" × 96" (122 cm × 244 cm)
Oil-based etching ink, batiste fabric,
ironing boards, composition leaf
Technique: Etchings printed on batiste
fabric

*"Elegy for Ellen" was created in
memory of the artist's grandmother,
Ellen A. Kames. The gold-leafed iron-
ing boards signal holiness of the
object; they are human-scale and are
folded to suggest Ellen's death, and
the etchings hanging in front are
printed on batiste fabric, traditionally
used for wedding and baptismal
gowns.*

MARTE NEWCOMBE

Night Rider

8" × 6" (20 cm × 15 cm)
Water-based ink
Technique: Silkscreen

*Newcombe scanned pictures of her
sculptures into the computer, manipu-
lated them, and then printed CMYK
separations; she then used traditional
silkscreen methods for the final print.*

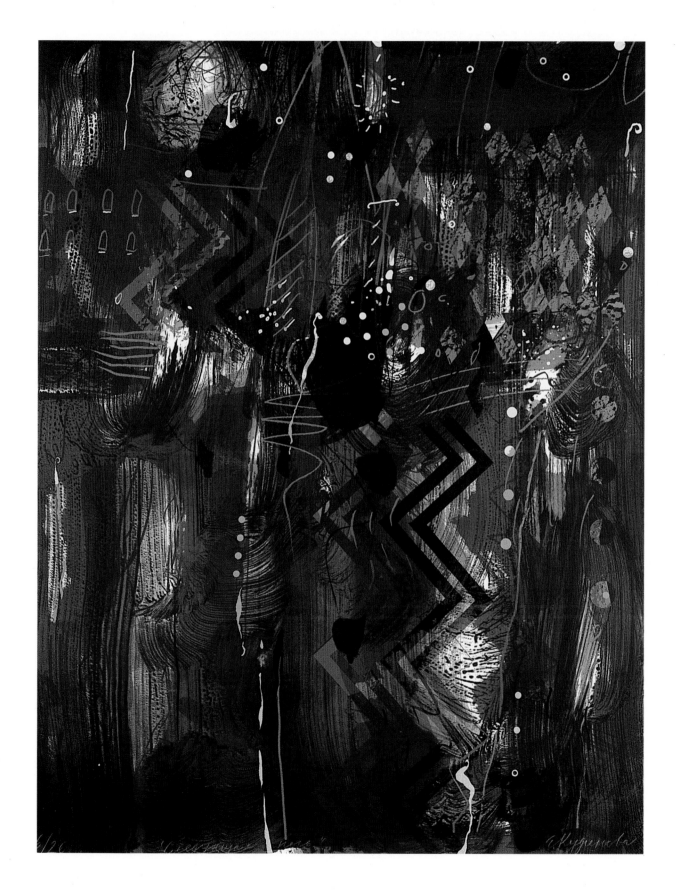

ELENA KUDINOOA

Next Night

29" × 22.5" (74 cm × 57 cm)
Water-based ink, Rives BFK paper
Technique: Silkscreen

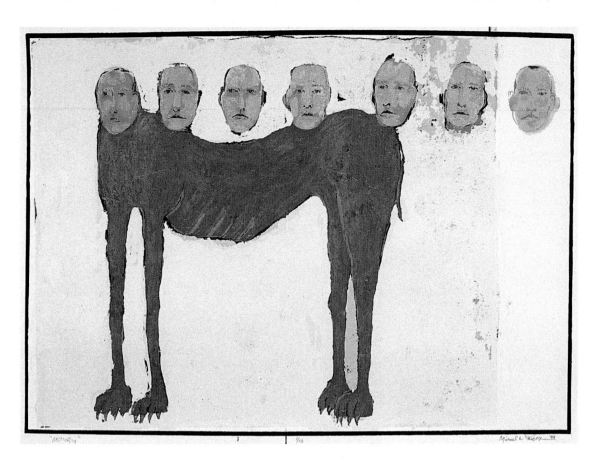

MICHAEL W. HECHT

Memory (and the Ability to Forget)

22" × 30" (56 cm × 76 cm)
Water-based ink, aquatint paper
Technique: Screenprint

*This is one of Hecht's many images of
mythological creatures as self-portrait;
he made at least twenty-five color
runs of this print, treating it some-
what like a painting.*

ROBERT ERICKSON

Natura LXII

70" × 23" (178 cm × 58 cm)
Oil-based ink, Arches Cover paper
(white)
Technique: Two-color monoprint

*This image used two colors and two
runs; the first run was pulled from a
plywood plate, and the second run
was pulled from an acrylic gel medium
plate.*

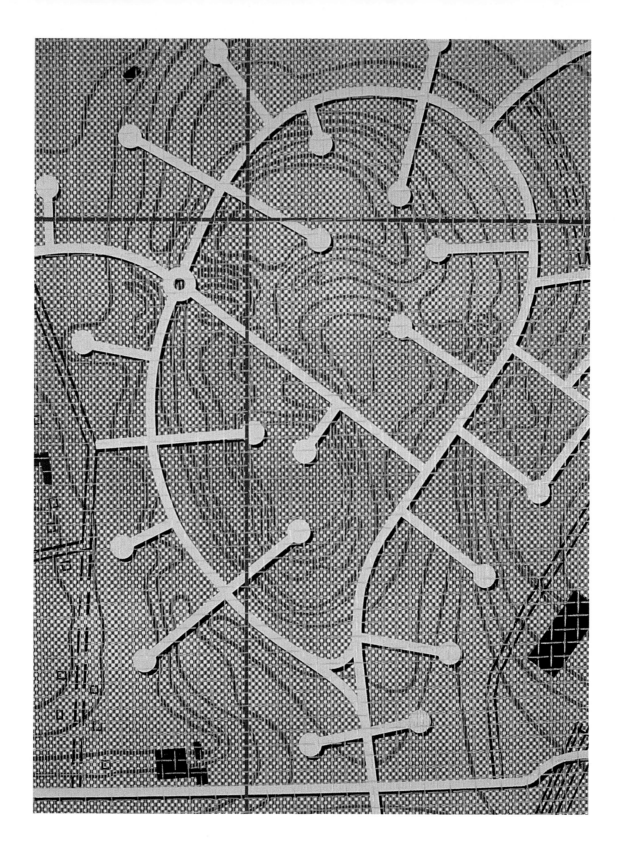

CARMELA VENTI

Anxiety

30" × 22" (76 cm × 56 cm)
Oil-based ink, Rives BFK paper (gray)
Technique: Relief, silkscreen

A series of dead-end streets in topographic style defines this map portrait (from "Places as Faces"); it is no wonder zoning no longer permits this configuration of streets.

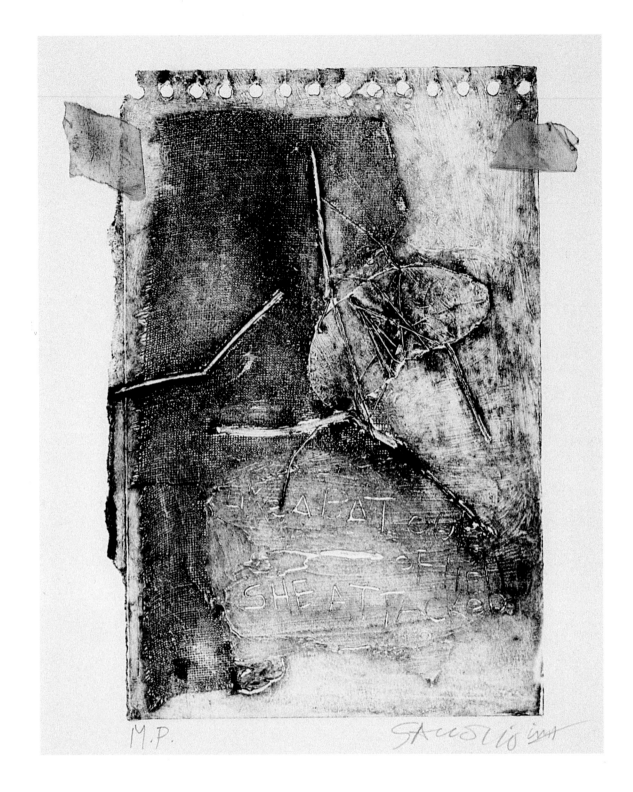

ROSANNA SACCOCCIO

Paper Roses for the Virgin #3

11" × 8.5" (28 cm × 22 cm)
Oil-based ink, Stonehenge paper
Technique: Collagraph, collage; artist
taped buckram, leaves and branches,
and string on cardboard slate

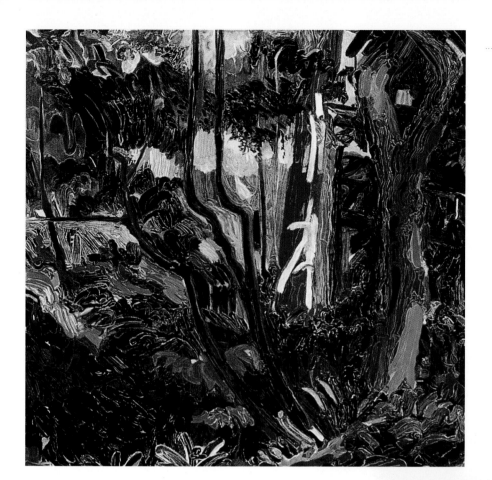

Olympia I

28" × 28" (71 cm × 71 cm)
Charbonnel ink, German etching paper
Technique: Aquatint on copper; three-color plates, bleed prints

Lisa Sweet

Unidentified Boiled Saint

Installed/Case Size: 21.5" × 30" × 3"
(55 cm × 76 cm × 8 cm)
Individual Tea Bags: 2.5" × 1.5"
(6 cm × 4 cm)
Oil-based ink, aquatint paper, Lipton tea bags
Technique: Etching on tea bag, photocopy transfer of computer-manipulated image

This piece is an example of Sweet's ongoing interest in combining 2D and 3D; it is based on a story about a saint who was martyred by boiling in tar.

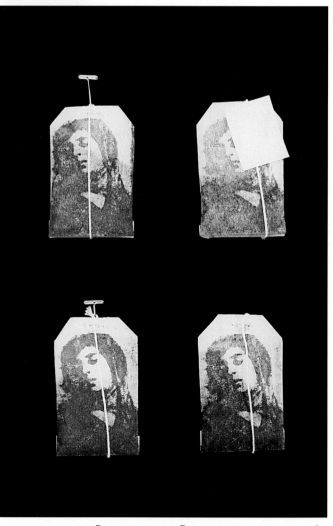

Elizabeth J. Peak

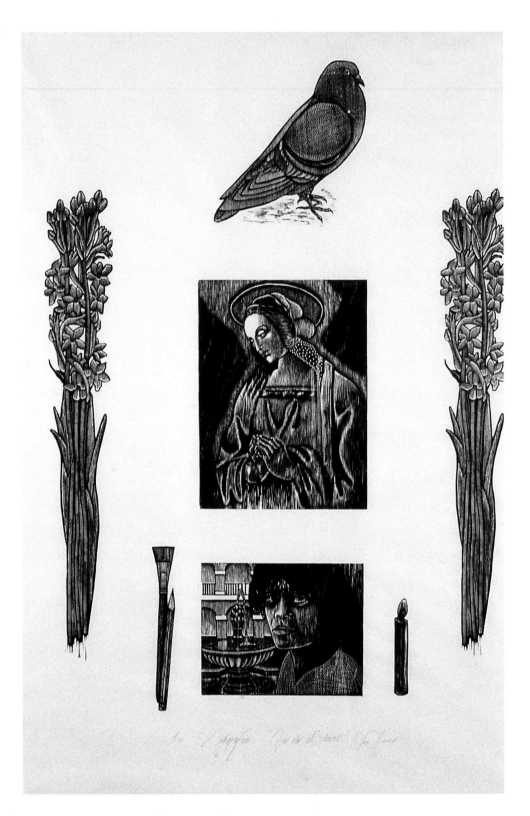

ORLANDO SALGADO
..

Que Ria el Silencio

24" × 48" (61 cm × 122 cm)
Technique: Woodcut over paper
tableau

*"Que Ria el Silencio" was created in
memory of Ismael Dieppa, a Puerto
Rican painter.*

Chain

18.5" × 28.5" (47 cm × 72 cm)
Etching ink, Whatman paper, zinc and
copper plates
Technique: Intaglio, etching, aquatint
(multiple plates)

*In "Chain" the artist focuses on the
sensuousness of texture and contrast-
ing values to heighten or transcend
the mundane—to speak of an under-
lying energy beneath immediate
perception.*

Complied Complex

25" × 35.5" (64 cm × 90 cm)
Lithograph ink on BFK paper
Technique: Lithography

*With a feeling of pleasure, the artist
freely and richly approaches the
world in which everything naturally
breathes its own breath.*

DENNIS APPLEBEE

M30

7" × 10" (18 cm × 25 cm)
Oil-based ink, Rives BFK paper (white)
Technique: Intaglio, chine collé

These images are from a large body of work dealing with architectural references and atmosphere to create space.

PATRICIA CUDD

...and there

30" × 22.5" (76 cm × 57 cm)
Oil-based ink, Arches Cover paper (black), Sekishu paper
Technique: Photo-lithography, chine collé

Searching back to find the present in the past, this image uses childhood nursery rhymes to say it all.

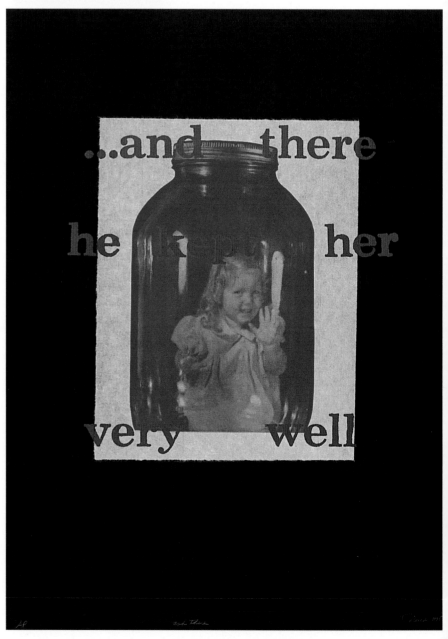

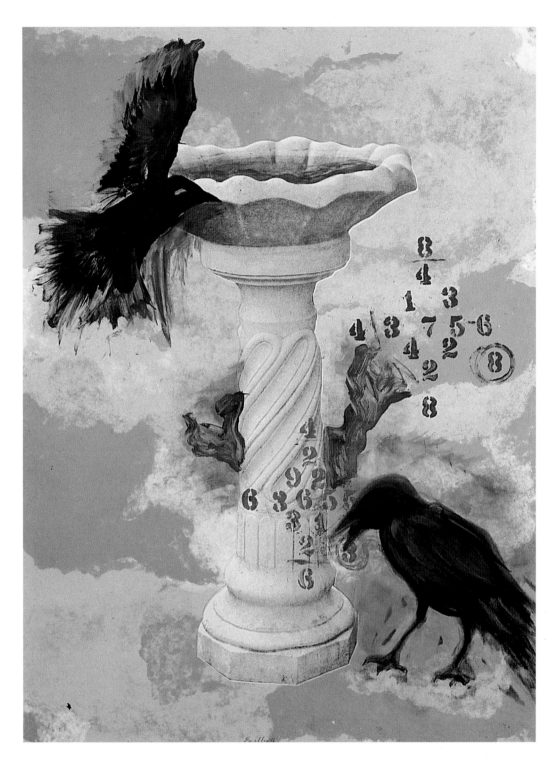

Birdbath

38" × 28" (97 cm × 71 cm)
Oil-based ink, handmade paper
(poured linen, recycled abaca, and
cotton)
Technique: Monotype, photo-litho-
graph, watercolor, chine-collé

*Crows began to appear in Hersh's
work with her return to family and
her roots on the East Coast; these
strong tenacious birds represent a
new beginning.*

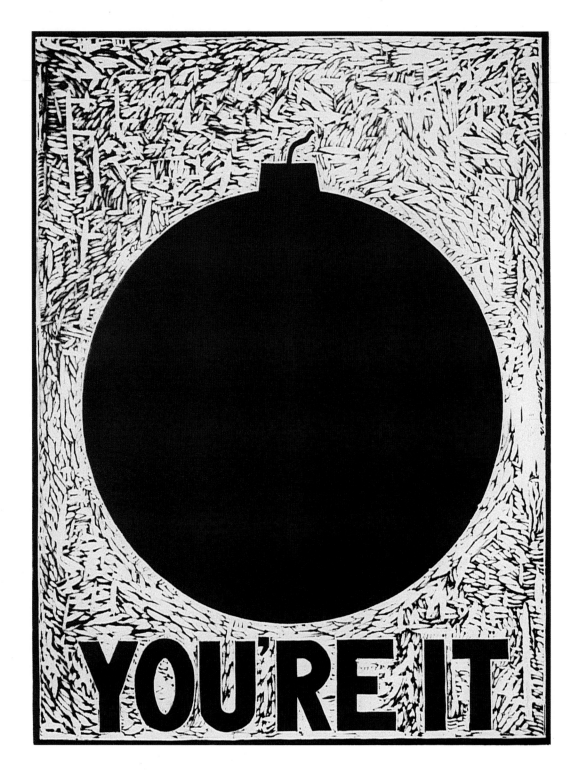

KRISTIN BROTEN

You're It

18" × 24" (46 cm × 61 cm)
Oil-based ink (black, light green),
Rives Lightweight paper
Technique: Two-color printing and
woodcut

*This is one of seven different prints,
using text and iconographic images,
that depict the humorous side of
"love gone bad."*

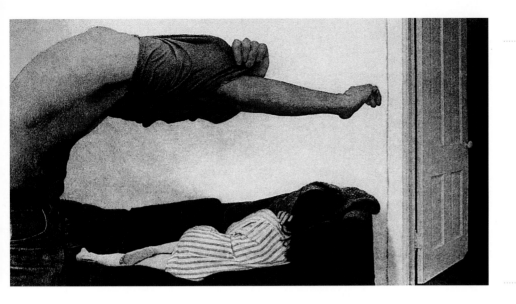

HARVEY BALL

Untitled (from "Taking Off" series)

9" × 17" (23 cm × 43 cm)
Ink (cool-tinted black), Saunders
watercolor paper (140 lb.)
Technique: Photo-intaglio; composite
image of photos, hand aquatint

This is one in a series of photo-intaglio pieces depicting couples in interiors.

FRANS WESSELMAN

Islanders

3" × 4" (8 cm × 10 cm)
Oil-based ink, Fabriano Rosaspina
paper (white, 285 gsm)
Technique: Etching/Relief

The print is one of a group in which the artist explored the mysteries of travelers—as they pass one another, their pasts and futures remain unrevealed.

HARVEY BALL

Quench

24" × 18" (61 cm × 46 cm)
Rives BFK paper, Rives Lightweight
paper, three plates
Technique: Photo-intaglio, chine collé,
inking à la poupée, intaglio wiping
with relief-rolled color

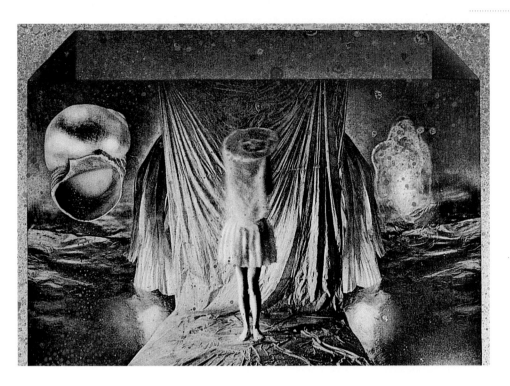

Exquisite Drifting

15" × 23.5" (38 cm × 60 cm)
Oil-based ink, water-based watercolor paint, Arches Cover paper (250 gsm)
Technique: Photo-etching, aquatint, watercolor monoprint

BALAZS PETER KOVACS

Kapuziner I

21" × 29" (53 cm × 74 cm)
Litho ink, pencil, brush
Technique: Lithograph in three colors (with brush and pencil)

Several brushes held together, making firm, energetic gestures, suggest a sense of concentrated power and speed, like the actions of a fencer who strives to win; Kovacs says he believes in non-casualness and improvised movements.

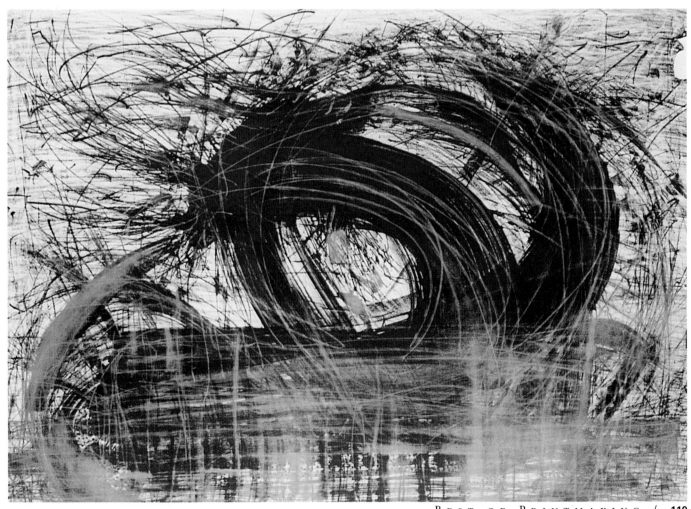

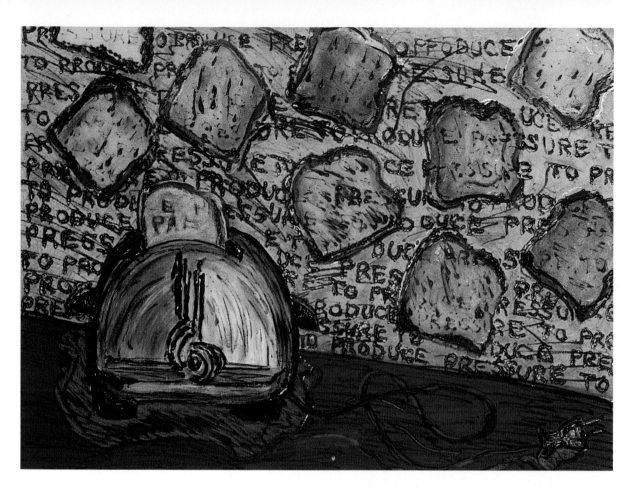

NANCY KELLAR

Pressure to Produce

18" × 28" (46 cm × 71 cm)
Oil-based ink, Rives BFK paper
Technique: Intaglio, drypoint, relief;
printed à la poupée and viscosity with
hand coloring.

*The idea behind this print was to use
flying toast and a toaster out of con-
trol to poke fun at the idea of feeling
pressured to produce and perform.*

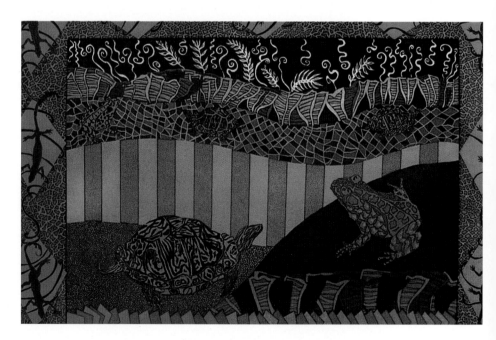

SAROJINI JHA JOHNSON

Nine Newts

24" × 36" (61 cm × 91 cm)
Oil-based ink, Rives BFK paper, zinc
plates
Technique: Color intaglio; three
plates with inking à la poupée

*This print is meant to evoke the
beauty and mystery of a garden in
the summer.*

Stella

12" × 21.5" (30 cm × 55 cm)
Fabriano 5 paper
Technique: Mixed metal

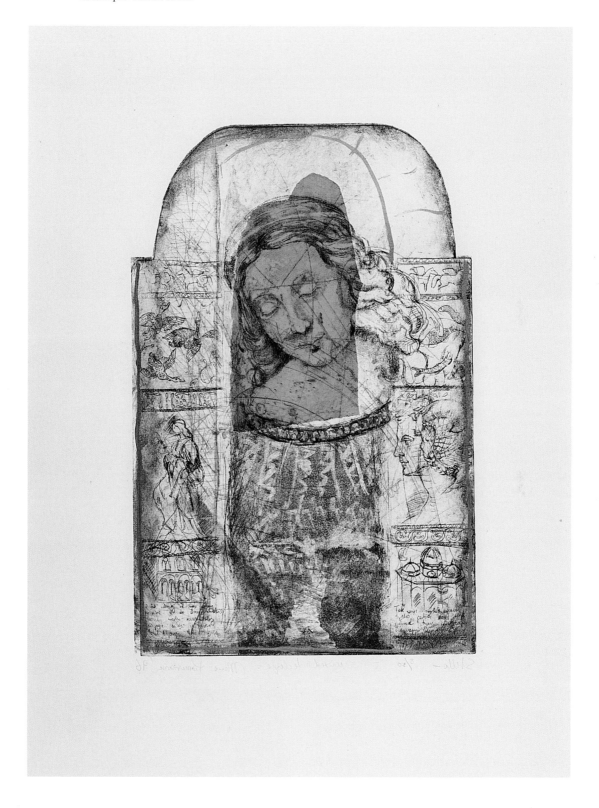

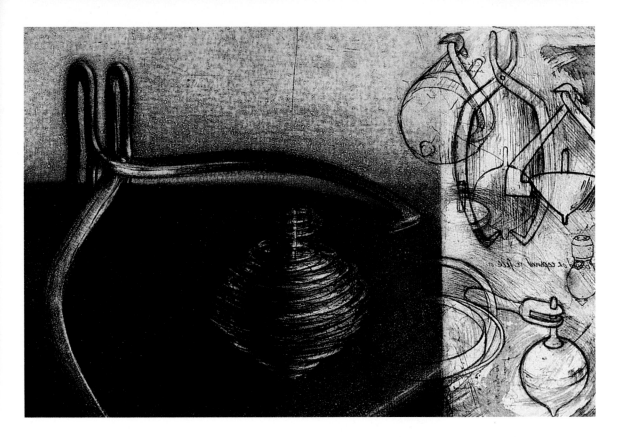

LARI R. GIBBONS

Stratagem

12" × 18" (30 cm × 46 cm)
Oil-based intaglio and lithograph
inks, Rives BFK paper (100% rag)
Technique: Color intaglio (etching
and drypoint), monoprint

*"Stratagem" depicts a staged battle
between two unlikely opponents: a
spinning plastic top and a pair of
threatening metal calipers; while by
their nature the calipers would seem
to be at an advantage, the top is elu-
sive and darts away from its adversary.*

STEPHANIE RUSS

Untitled II

21" × 17" (53 cm × 43 cm)
Oil-based inks, rice paper, Rives BFK
paper
Technique: Lithography, chine collé,
rubbing

*Russ's work evolves intuitively as she
draws inspiration from her own
emotional responses to the changing
environment, hoping to create an
internal landscape which captures
the essence of nature in motion.*

Larry's Director Chair

18" × 12" (46 cm × 30 cm)

Graphic Chemical etching ink (#514 black), Rives BFK paper (white)

Technique: Intaglio etching, soft ground, line etching

Schmidt used etched line, soft ground tones, and foreshortened positioning of her husband to create a flat/deep space ambiguity or positive/negative effect.

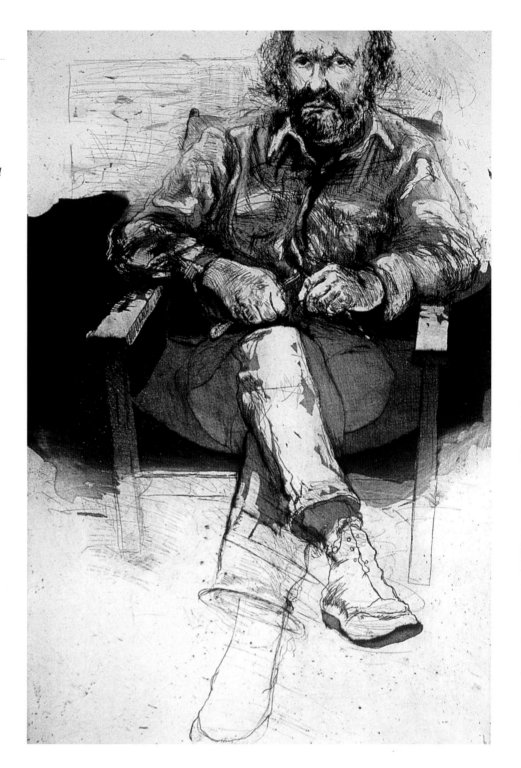

Language As Aphasia

72" × 40" (183 cm × 102 cm)
Oil-based ink, Arches Cover paper
Technique: Intaglio with three color plates and one black-and-white plate, aquatints, photo-etching

As a feminist, Bernardi is interested in the universe contained in the body and the difficulty in using language to communicate emotion and the totality of life's experiences.

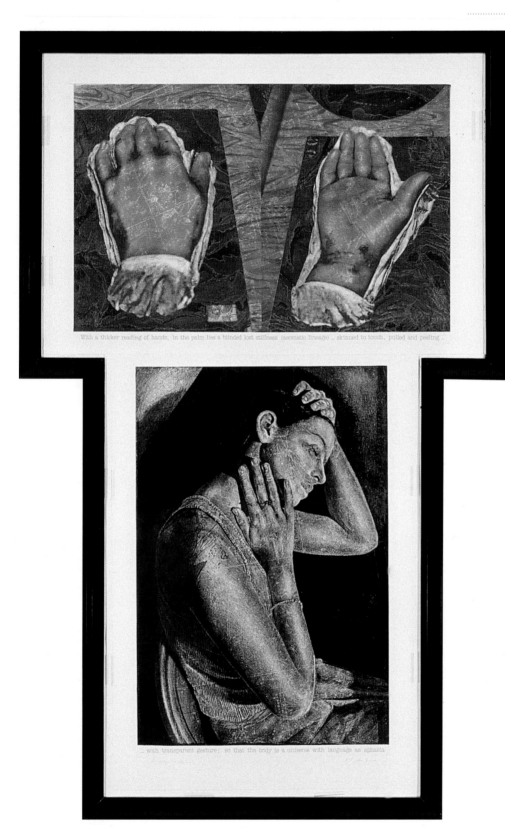

With a thicker reading of hands, in the palm lies a blinded lost stillness (axomatic lineage) ... skinned to touch, pulled and peeling ...

... with transparent gesture; so that the body is a universe with langua(g) as aphasia

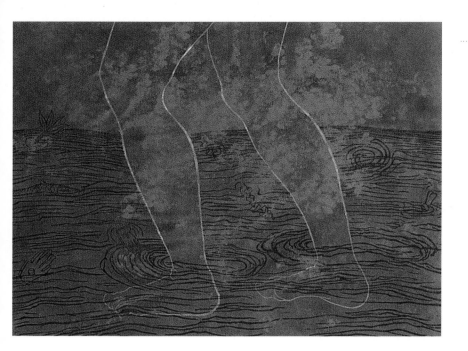

JUDY YOUNGBLOOD

Bad Sense of Direction

22" × 30" (56 cm × 76 cm)
Oil-based inks, Sekishu paper, bronzing
powder
Technique: Relief print printed from
linoleum, added bronzing powder

KRISTEN ELLSWORTH

*You Are Not Here to Cry About the
Miseries of Mankind*

3" × 3" (8 cm × 8 cm)
Oil-based ink, Rives BFK paper (white)
Technique: Intaglio, watercolor

The red umbrella expresses determination, courage, and strength in what may seem to be unpleasant circumstances.

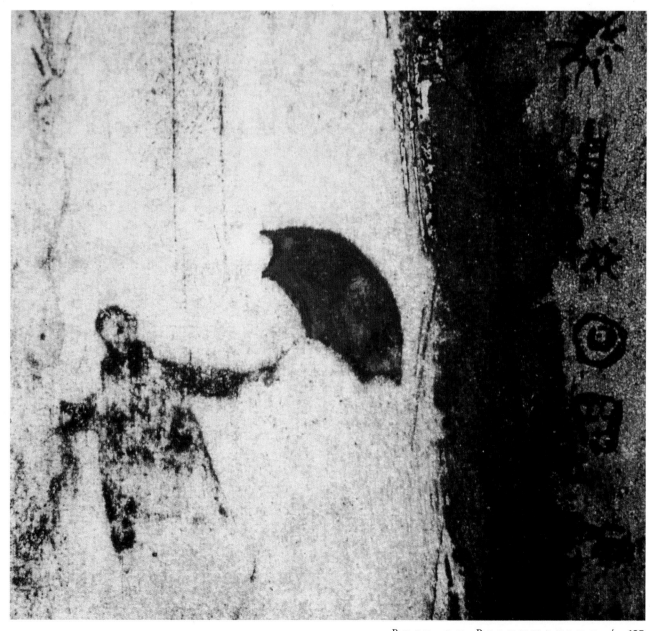

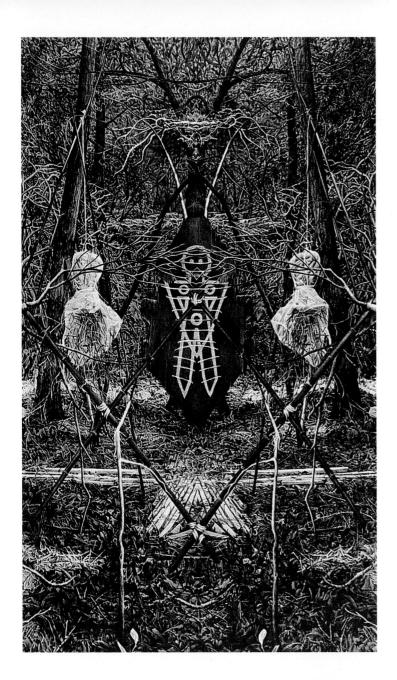

DAVID MORRISON

Penland Spirit at Vermillion

19" × 11" (48 cm × 28 cm)
Rives BFK paper
Technique: Lithography

This lithograph focuses on a sculptural installation that Morrison has constructed at Penland, NC; the print examines the relationship between nature, spirituality, and the artist.

BARBARA ZEIGLER AND
JOAN SMITH

Earthmakers

24" × 36" (61 cm × 91 cm)
Oil-based ink, Kozo paper, cedar
Technique: Photo-etching

The focus here is on the wonder and diversity of that which is literally right beneath our feet; this piece is an homage to the millions of inhabitants of a square meter of forest soil.

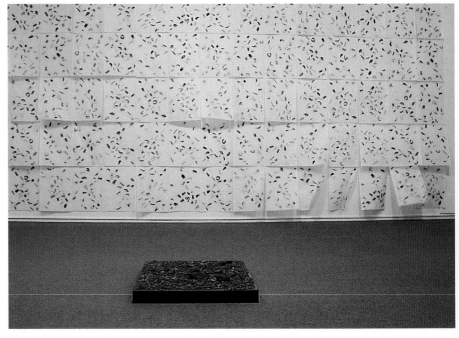

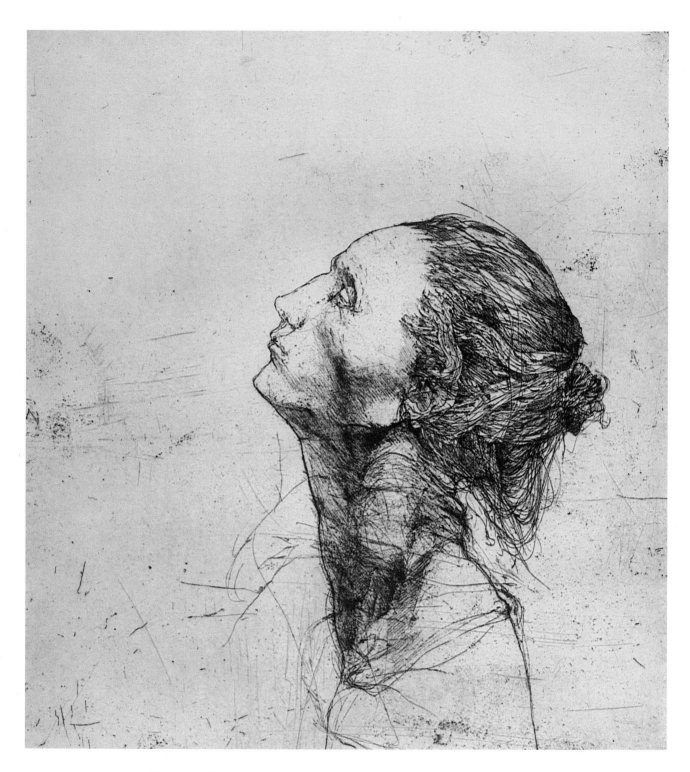

GEORGE HAWKEN

Grete

14" × 18" (36 cm × 46 cm)
Charbonnel oil-based ink (black),
Arches paper (300 gsm)
Technique: Line etching on copper, soft
ground

*Part of "Kafka's Metamorphosis," a
suite of twelve intaglio prints, this
image was published in an edition of
thirty-five.*

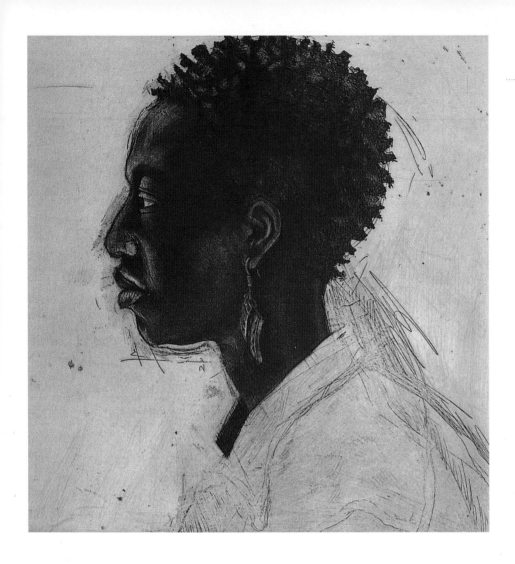

PHILIPPE BAUMANN

NPKM

12" × 12" (30 cm × 30 cm)
Charbonnel oil-based ink, Rives BFK paper (white)
Technique: Intaglio

This is one in a series of three iconographic images of women that attempt to render the image as object/icon.

E. J. HOWORTH

Mental Migration

15" × 20" (38 cm × 51 cm)
Water-based screen ink, Somerset paper
Technique: Screenprint

This image involves Howorth's personal links between mental and physical, warm and cold climates, fantasy and reality, history and the present.

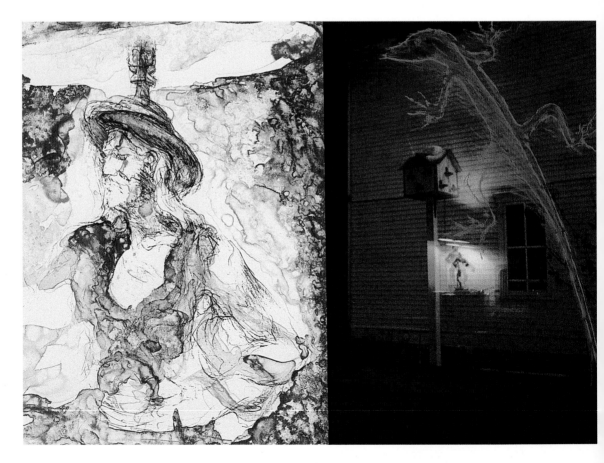

KRISTEN ELLSWORTH

*Do Not Be Fooled, Something
Good Is Happening Every Day*

3" × 3" (8 cm × 8 cm)
Oil-based ink, Rives BFK paper (white)
Technique: Intaglio

*This is from a book of HOPE etch-
ings; according to the artist, the fish is
the "something good."*

MARIA LINDSTRÖM

Silento II (Triptych)

38.5" × 27.5" (98 cm × 70 cm)
Fabriano Rosaspina paper
Technique: Lithography, marble stone,
tusche

ADRIANE HERMAN

Draw Something Funny

9" × 6" (23 cm × 15 cm)
Oil-based etching ink, Rives BFK paper
Technique: Intaglio monoprint, chine collé with a window that bends out

Working with a palette of plates etched with images, games, food, and workbooks, Herman layers images that evoke memories of childhood, making analogies with how we learn, from images then from words.

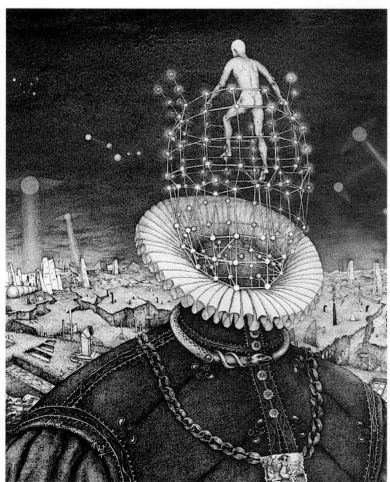

NELE ZIRNÍTE

Ruler

16" × 13.5" (41 cm × 34 cm)
Russian paper
Technique: Etching

Here the image reflects an impulse—an urgent demand—to point out the conflict between urbanization and surrounding environmental processes, the demoralizing and demolishing role of the "man of genius"; all this makes one meditate on contemporary mysteries and value oneself through opposite streams of epochs and thoughts—up to the future.

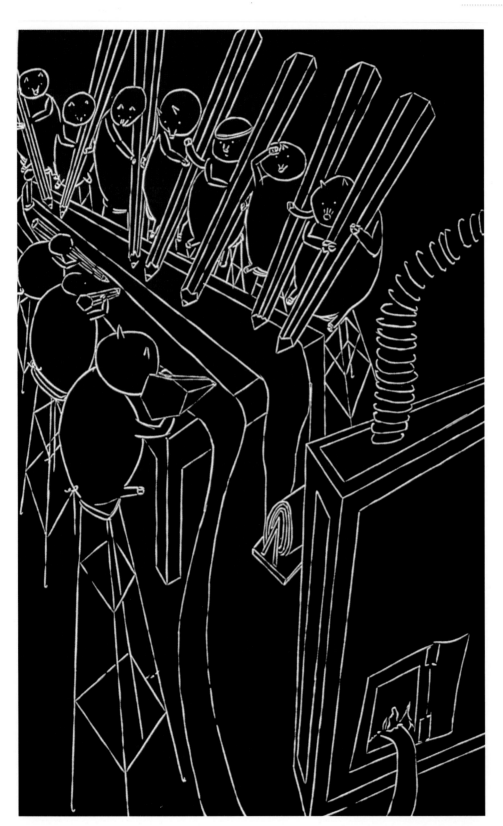

Enormous Daily Labours

50" × 30" (127 cm × 76 cm)
Oil-based ink, Seichosen Kozo paper
Technique: Woodcut, spoon-printed

This image is based on George Orwell's Animal Farm; *the pigs are too busy with "mysterious things called reports, dossiers, memorandums, and files" to participate in farmwork, and these harried bureaucrats reflect our own preoccupation with paperwork.*

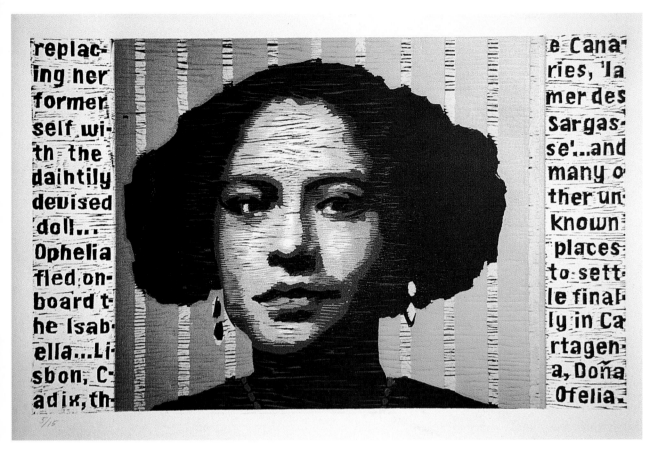

replac-
ing her
former
self wi-
th the
daintily
devised
doll...
Ophelia
fled on-
board t-
he Isab-
ella...Li-
sbon, C-
adix, th-

e Cana-
ries, 'la
mer des
Sargas-
se'...and
many o-
ther un-
known
places
to sett-
le final-
ly in Ca-
rtagen-
a, Doña
Ofelia.

JEAN LODGE

Ophelia Lives

25.5" × 35.5" (65 cm × 90 cm)
Oil-based ink, Rives BFK paper
Technique: Woodcut, multiple block

In this work the artist invents a new version of Hamlet *in which Ophelia did not drown, but instead escaped to the New World.*

BETH GRABOWSKI

Evidence, Mindful, Revealed

40" × 90" (102 cm × 229 cm)
Water-based silkscreen ink, Mylar film
Technique: Silkscreen on Kodalith transparencies with pigment offset on wall

This piece explores the assertion and acknowledgment of the independence and connection between mother and child (daughter).

ANNE KARSTEN

Maternity

14" × 10" (36 cm × 25 cm)
Oil-based ink, Rives BFK paper
Technique: Photocopy, gum print

Karsten is interested in how digitization has changed the representation of "reality" in images that are photographic in nature.

BERNICE FICEK-SWENSON

Putting Out Ashes I

8" × 10" (20 cm × 25 cm)
Oil-based ink, Arches 88 paper, gampi silk tissue
Technique: Photogravure etching, chine collé

Ficek-Swenson works from still lifes of ashes, stones, and cremated bones, universal materials with eternal messages; photogravure etching "carries the metaphor" with elegance and velvety softness.

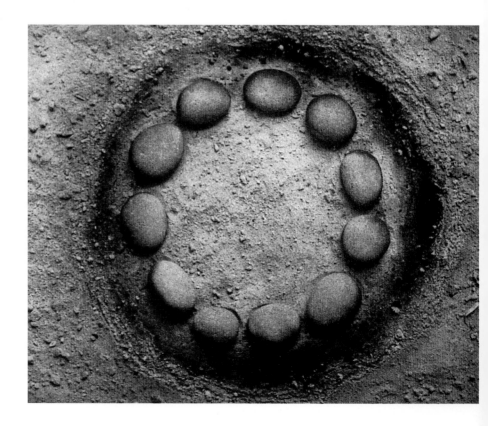

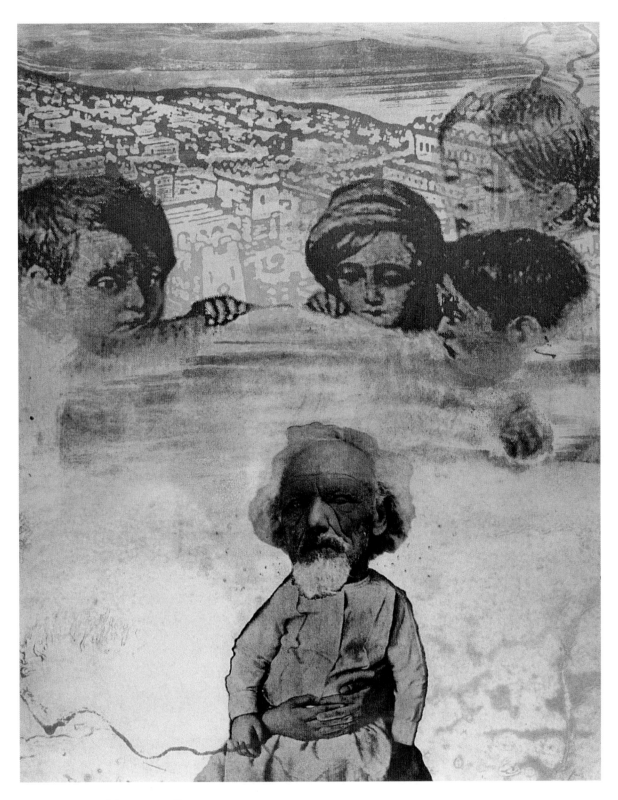

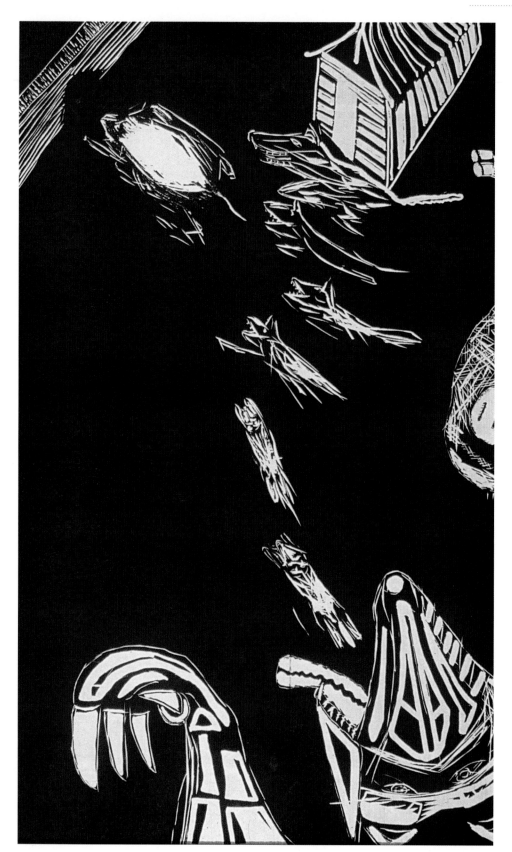

Napoleon Signals the Purge

50" × 30" (127 cm × 76 cm)
Oil-based inks, Seichosen Kozo paper
Technique: Woodcut, spoon-printed

This image is based on George Orwell's Animal Farm; *one pig's logic is countered by Napoleon's wolfhounds, and thus brute force clears the field of opponents and notions of equality.*

Diptych

20" × 32" (51 cm × 81 cm)
Oil-based inks, handmade paper (sisal
fiber, carrot pulp)
Technique: Relief

*This piece demonstrates a simple
system of covering a surface, while
exploring an intuitive organization of
energy.*

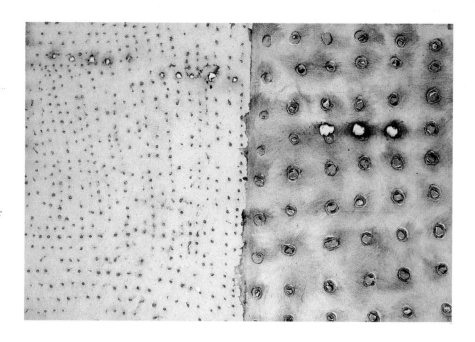

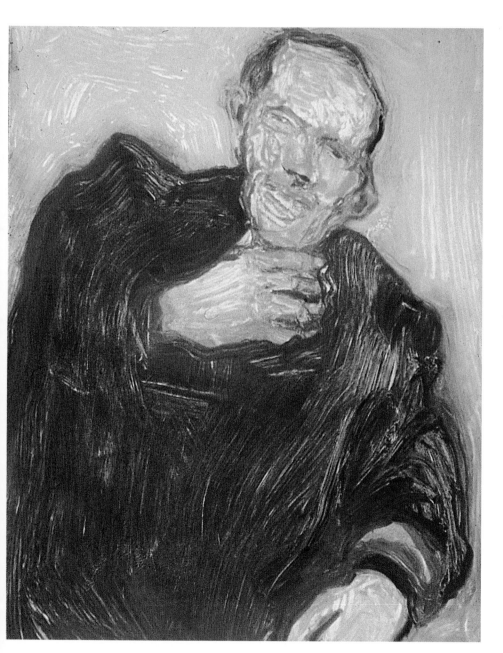

TERESA T. SCHMIDT

Portrait of Soutine

15" × 12" (38 cm × 30 cm)
Oil paint, turpentine, Rives BFK paper
Technique: Single-drop monotype

DAVID CONN

Damascus No. II

8" × 7" (20 cm × 18 cm)
Daniel Smith oil-based etching ink,
Charbonnel paper, Fabriano paper,
Rives BFK paper
Technique: Etching, chine collé

David Conn's prints search to recapture dreams or express content in such a way as to evoke myths, such as the female muse figure seen in much of his work.

MARINA RICHTER

Melancholy With a Broken Iris/Hommage à Peter Bruegel

19.5" × 16" (50 cm × 41 cm)
Simili Japon Van Gelder paper, Stones No. 7 crayons
Technique: Lithography

In this image, blind people fell and broke an iris growing in a gorge; while the blind people are no longer living, the artist has the iris as a memory and a warning.

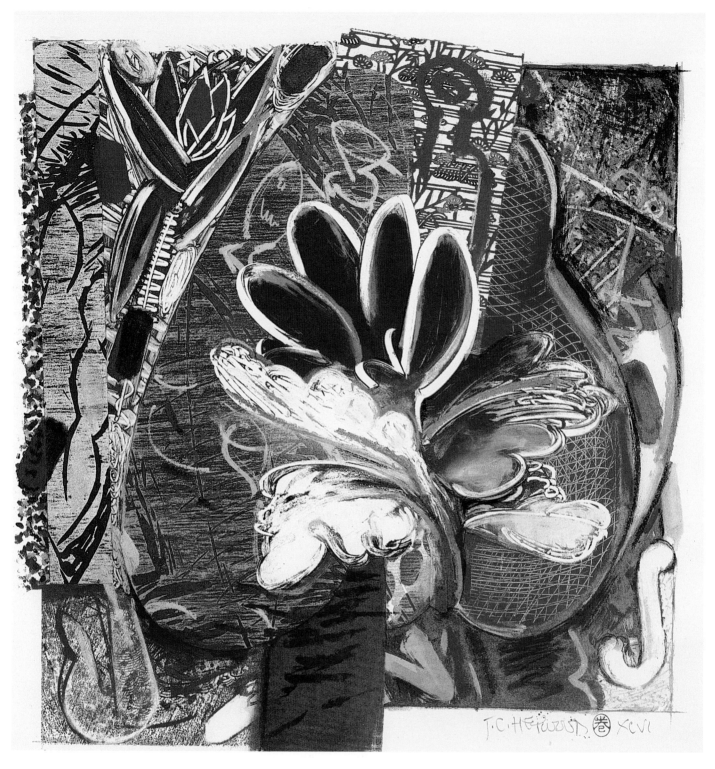

J.C. HEYWOOD

Layers & Layers

21" × 15" (53 cm × 38 cm)
Water-based screenprinting ink, Arches
88 paper
Technique: Radiation-cured screen-
print

Crying—Diseases of the Heart and Mind

36" × 26" (91 cm × 66 cm)
Oil-based ink, Rives BFK paper
Technique: Wood intaglio, lithograph, relief, Kodalith chine collé

"Crying—Diseases of the Heart and Mind" is one in a series of twelve images in which symptomology from Tibetan medicine is combined with images of real and imagined tools and western perspective; the materials and print processes support the conceptual basis of the work.

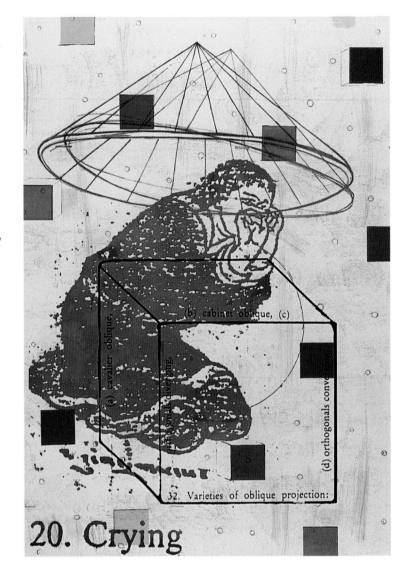

GUNTARS SIETINS

Levitation II

13" × 26" (33 cm × 66 cm)
Charbonnel ink (black, green, blue), Russian etching paper
Technique: Mezzotint

The ground in this print was prepared with 100-gauge rockers.

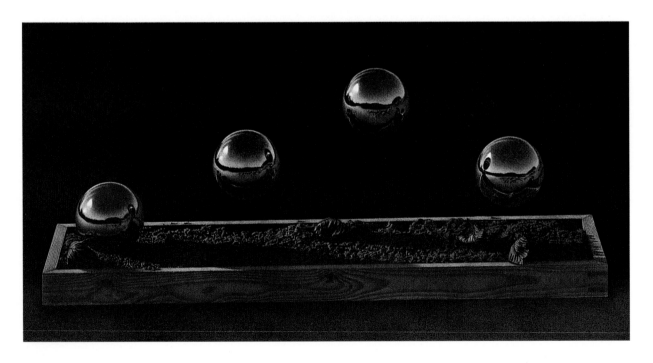

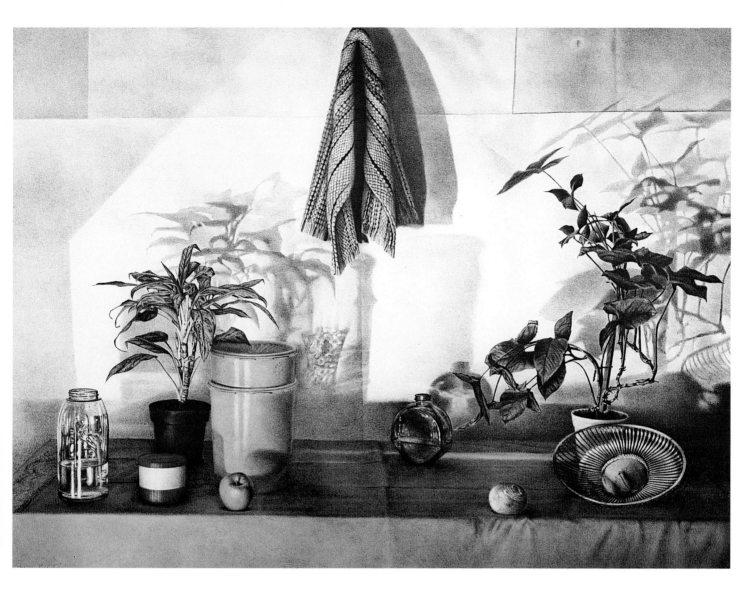

JAMES D. BUTLER

Warner Still Life

27.5" × 37.5" (70 cm × 95 cm)
Oil-based ink, calendered Rives BFK
paper
Technique: Lithography in three col-
ors: two aluminum plates and one
stone plate

*Butler has worked with still-life and
landscape subjects for the past thirty
years, using his own environment as
a source for his work.*

RAYMOND LOUIS GLOECKLER

Crown II

22" × 36" (56 cm × 91 cm)
Oil-based ink, Sekishu paper
Technique: Woodcut (relief)

*"Crown II" is forcefully cut; agitation
of the negative space creates a feeling
of torment, and the manner in which
the block is cut lends strength to the
shapes the cutting delineates.*

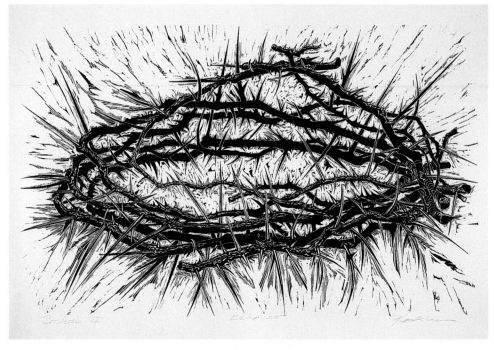

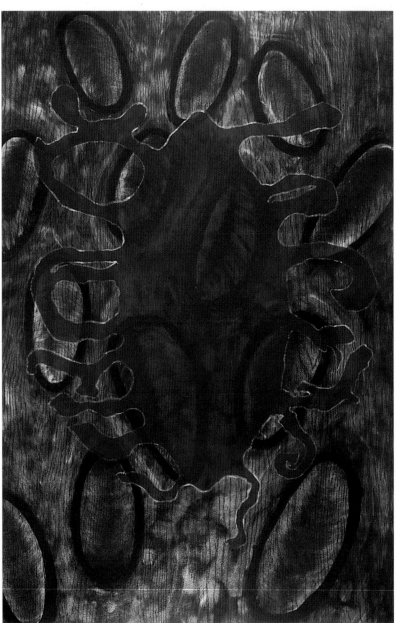

CATHERINE WILD

Skinfish

35" × 23.5" (89 cm × 60 cm)
Oil-based litho ink, Rives BFK paper
Technique: Woodcut, monotype, hand-
coloring with litho ink

*Wild's work divides into two oppos-
ing sensibilities—one very physical
and confined, the other weightless,
transcendent and hovering; her sensual
forms are in a process of constant
change and growth.*

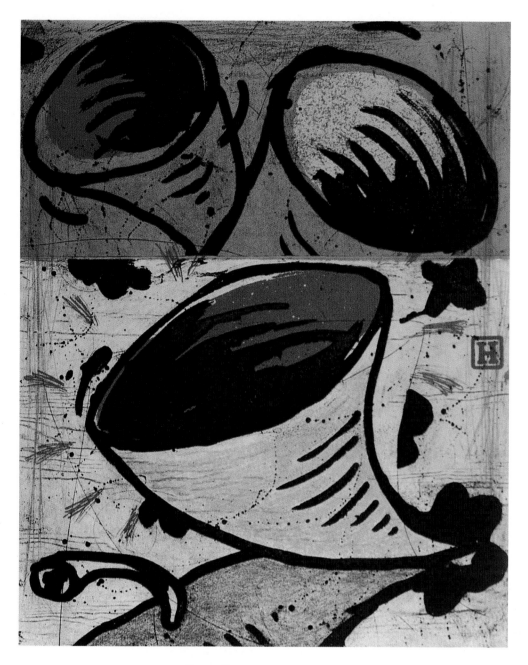

RON GARRETT

Gabriel's Horn

22" × 18" (56 cm × 46 cm)
Oil-based intaglio ink, Kitakata
Moriki paper, Rives BFK paper
Technique: Sugar-lift etching, aquatint,
chine collé

Tribeca

10.5" × 7" (27 cm × 18 cm)
Ink (brownish-black), CMF etching
paper
Technique: Intaglio: aquatint etching;
print is hand-drawn, not a photo
process

*"Tribeca" (Triangle below Canal
Street) is a view of lower Manhattan
with the World Financial Center
buildings on the left.*

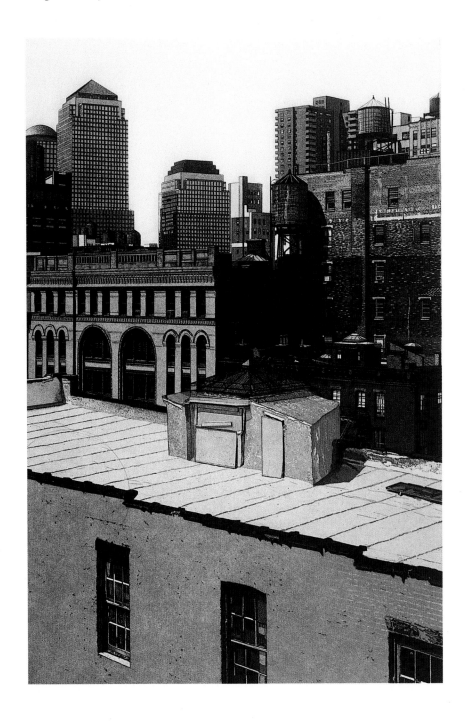

Queue

46" × 30" (117 cm × 76 cm)
Oil-based ink, Arches paper (buff),
acrylic paint
Technique: Monoprint, collagraph,
photocopy transfer with found collage
materials

*This piece addresses a sense of subtlety
and rarity in human interaction or
connection.*

TOM NAKASHIMA

Turtle

48" × 36" (122 cm × 91 cm)
Oil-based ink (brown, black), Rives
BFK paper (white)
Technique: Intaglio, newspaper collage
hand-painted with watercolors; two
colors printed with copper plates

*All of his images are arrived at with-
out intention of symbolism,
Nakashima says; they come to him
like dreams—only later does he think
about what they might mean.*

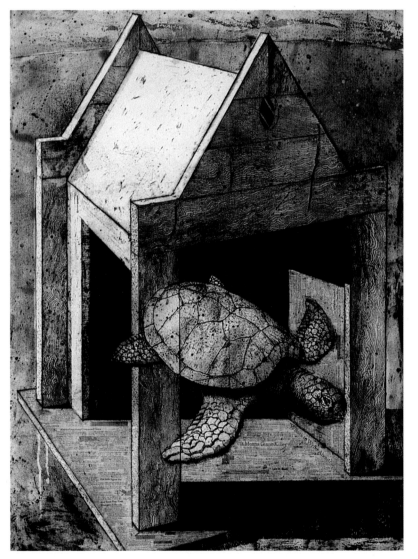

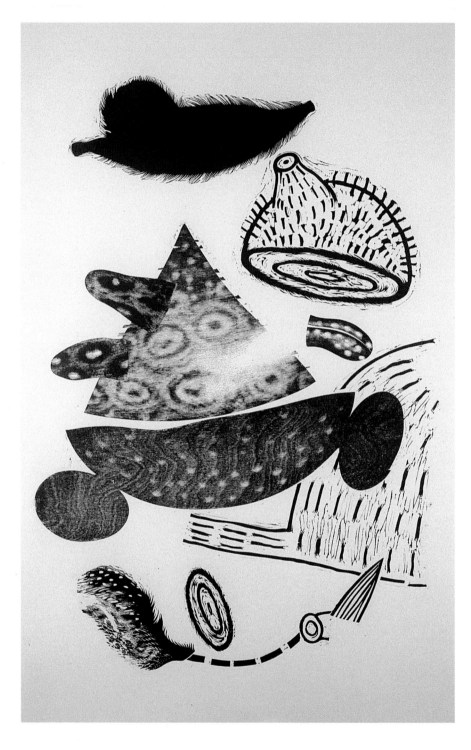

Untitled

39" × 26" (99 cm × 66 cm)
Oil-based block printing ink, linoleum,
birch plywood, Somerset Satin paper
Technique: Relief woodcut, linocut

*These prints reflect an interest in the
mysterious structures and events in
nature; the images encompass muta-
tion, evolution, repulsion, attraction,
familiarity, strangeness, deterioration,
and the potential for new existence.*

D E B O R A H M A E B R O A D

Dark Dog

18" × 24" (46 cm × 61 cm)
Oil-based inks, Basingwerk paper
Technique: Intaglio Etching, soft
ground, aquatints, tusche wash,
scraping and burnishing

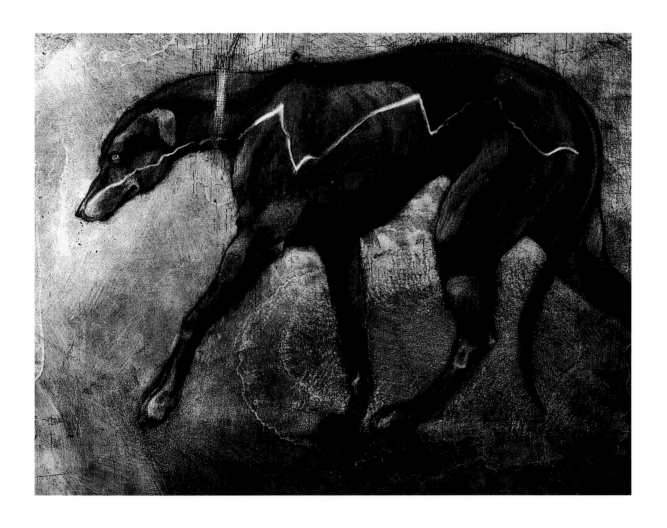

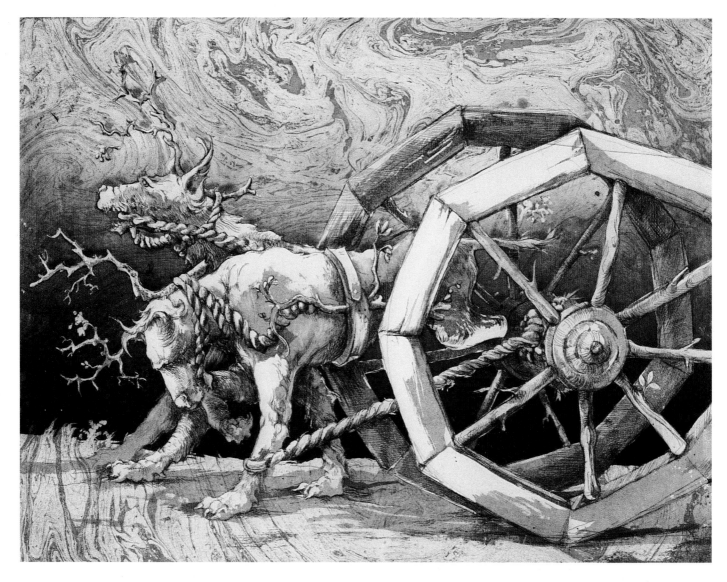

RALPH D. SLATTON

The Lesser of the Two Evils

18" × 24" (46 cm × 61 cm)
Oil-based Frankfort ink (black),
Copperplate paper
Technique: Intaglio, using line etching
and aquatint on a copper plate

*The image implies an apocalyptic
event, through its use of energetic sky,
its moody directional lighting, and its
beastly subject matter; as the struggle
continues, the burden becomes more
impossible.*

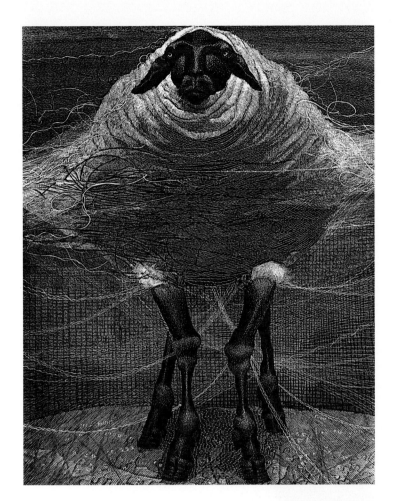

DEBORAH MAE BROAD

Portrait of the Artist as a Young Teacher II

10" x 8" (25 cm x 20 cm)
Oil-based ink, Fabriano Magnani Incisioni paper
Technique: Wood engraving (relief)

CHARLES H. COHAN

Untitled Part I

28.5" × 22" (72 cm × 56 cm)
Handschy Litho ink, Daniel Smith intaglio ink, Rives BFK paper
Technique: Lithograph (relief and intaglio) with one litho stone, two litho plates, two relief blocks, and one intaglio plate, hand-drawing, photocopy transfer

This is Part I of a two-part homage to the late Abebe Bikila, the great Ethiopian Olympic runner who was tragically injured and paralyzed.

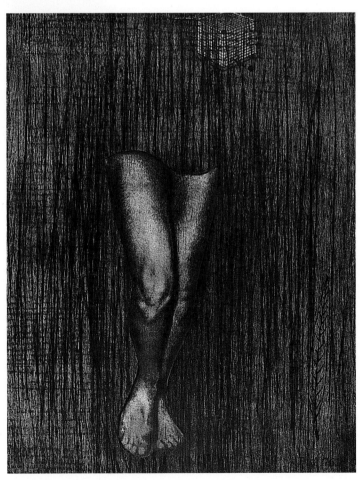

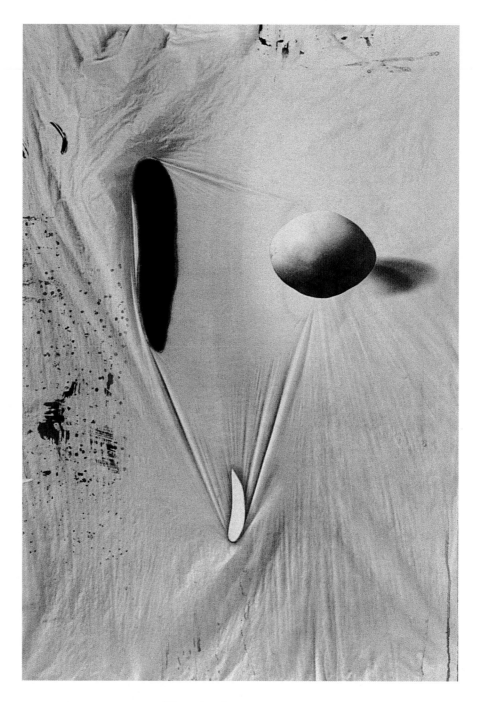

WALTER JULE

Measurement of Void

40" × 30" (102 cm × 76 cm)
Tosa gampi paper, Somerset Satin
paper, three plates
Technique: Etching, lithography,
chine collé

*In this image, compressed layers of
fragility create a tensioned field of
energy between mind and experience.*

JANIS JACOBSON

Legend of the Magic Trunk

20" × 19.5" (51 cm × 50 cm)
Water-based TW-Graphics screenprint-
ing ink, Rives BFK paper (250 gsm)
Technique: Silkscreen

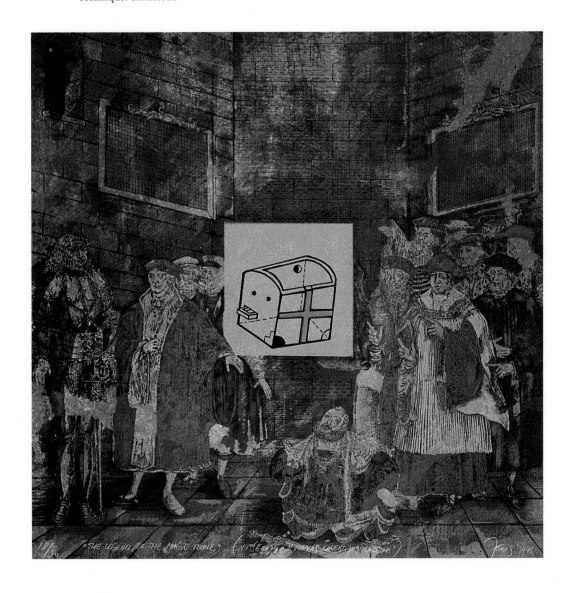

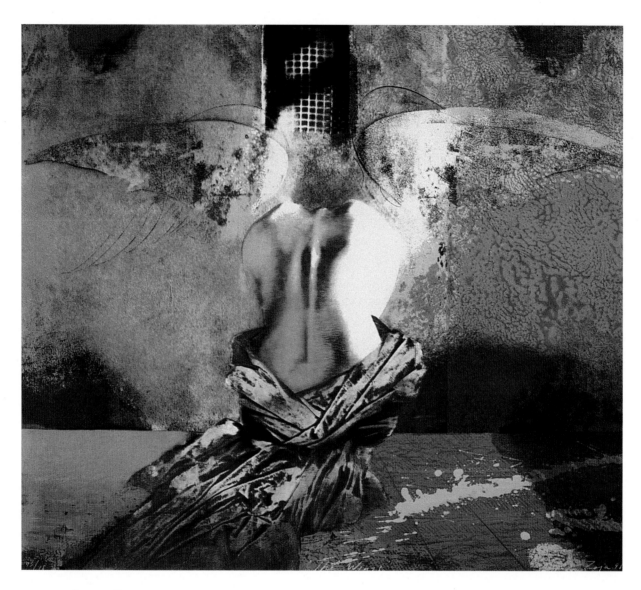

ZOYA FROLOVA

Wings

30" × 35" (76 cm × 89 cm)
Water-based TW-Graphics screenprint-
ing ink, Rives BFK paper (250 gsm)
Technique: Silkscreen

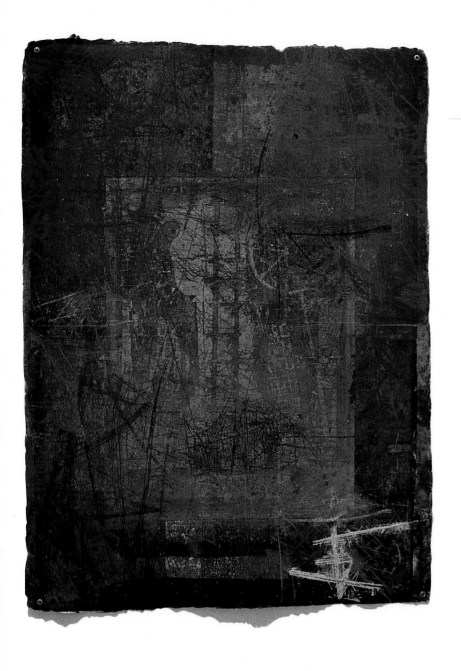

SERGEI TSVETKOV

Ancient Parable

30" × 40" (76 cm × 102 cm)
Etching ink, Graphic Chemical litho ink,
handmade paper, pulp painting medium,
dry pigments, bronze leaf
Technique: Etching

INGRID LEDENT

Z.T. '96 X

18" × 40" (46 cm × 102 cm)
Oil-based Daniel Smith ink, Whenzou
Chinese paper, methylcellulose
Technique: Lithograph (printed from
several stones), woodcut; mounted in a
wooden box

*Ledent's work combines simplicity of
form and versatility of symbols with
austere precision of technique, free-
dom and independence of thought
with intimacy and spontaneity of per-
sonal expression; the principal idea is
communication.*

ERIK EDSON

Transformation!

14" × 11" (36 cm × 28 cm)
Water-based screen ink, litho ink,
photocopy transfer
Technique: Lithograph, silkscreen,
collage

GLOSSARY

a la poupée: intaglio method in which several colors may be printed at once from a single plate. Each color is selectively applied to specific regions of the plate using a separate pad or rolled piece of felt.

aquatint: method in which porous, acid-resistant ground is applied to metal plates for tonal effects. Acid bites into the plate around the fine rosin particles. Areas can be stopped out and re-etched for different tonal effects.

chine collé: method of applying thin Eastern papers to a printed image for added color or tonal definition, usually applied when printed.

cliché verre: a print made photo-mechanically from an image needled through a light-resistant coating applied to a glass plate.

collagraph: a print made from a specially constructed plate that has been produced in a collage manner, resulting in high and low surfaces which hold ink differently during printing.

collotype: high-quality reproduction process using a gelatin-coated glass plate. Also called heliotype and photo-gelatin printing.

drypoint: intaglio technique in which a sharp point us used to incise a line into a metal plate; the line holds ink, as does the resultant burr yeilding a soft, smoky tone.

duotone: print with only two shades of a color or black and a colored tint.

electrotype: a duplicate printing surface made by taking a wax mold of the original surface and coating it with a thin layer of copper by means of electroplating.

etching: intaglio technique in which acid is used to incise lines into a metal plate. Includes aquatint, lift grounds, soft ground, hard ground, and the like.

halftone: photographic image that has been broken up into dots of varying sizes to achieve the effect of a full range of tonalities.

helio-gravure: photomechanical intaglio printing process; the older method of photogravure.

intaglio: printing technique in which paper is pushed into depressed or recessed lines on a metal plate and filled with ink. Includes aquatint, etching, engraving, mezzotint, and drypoint.

letterpress: a relief method in which metal or wooden type is assembled or composed; only the top surfaces are inked and printed.

lift ground: a plate-making technique in which a substance is applied directly onto a clean plate, with an acid-resistant ground applied over the top. The initial substance is "lifted" or washed out from beneath the ground, revealing an area of the plate that can be etched with acid.

linoleum print: a relief print in which the image is carved into linoleum. Also called a lino cut.

lithography: technique in which the image areas on a lithographic stone or metal plate are chemically treated to accept ink and repel water, while the non-image areas repel ink and accept water.

mezzotint: intaglio plate-making method of working from dark to light. The plate surface is roughened, then selectively scraped and burnished smooth in areas so as to hold ink differently during the act of printing.

monoprint: a combination of monotype and traditional printmaking methods pulled in an edition of one.

monotype: a print made in an edition of one, often from a painting made on a non-absorbent surface.

offset printing: method of printing in which the image is transferred from the plate onto an intermediary, such as a roller, and then onto paper, resulting in a final printed image that is not reversed.

photogravure: an intaglio platemaking process in which an image is photo-mechanically transferred onto a plate carrying etched hollows of similar size, but varying depth, creating a range of values in the final print.

pochoir: a stencil method of printing.

relief: printmaking technique in which the image is printed from a raised surface, usually by cutting away non-image area. Includes lino cut, woodcut, relief collograph, relief etchings.

serigraphy: technique that uses a squeegee to force ink through selected parts of stretched mesh containing the image. The image on the mesh can be produced either photographically, by cutting stencil, or by drawing direct with a block out material. The process is also called silkscreen.

soft ground: a plate-making method in which a tacky, acid-resistant ground is applied, then drawn or pressed into, revealing areas of metal that may be etched with acid.

woodcut: relief print made on the plank side of block of wood.

wood engraving: relief print made on the end grain of a block of wood. The relief areas are inked and printed.

About the Judges

And they brought smallpox

18" × 28" (46 cm × 71 cm)
Lithography, monotype, and
chine colle

LYNNE ALLEN, a well-known artist, master printer, and educator, is currently an Associate Professor of Art at Mason Gross School of the Arts, Rutgers University, and Associate Director of the Rutgers Center for Innovative Print and Paper. Allen exhibits her work regularly, having shown at the Susan Teller Gallery, Granary Books, and Mimi Fertz Gallery in New York City; the Corcoran Gallery of Art, Washington, D.C.; the 21st Ljubljana Print Biennial; and the International Print Triennial in Skopje, Macedonia. She is the recipient of the first Fulbright Scholarship awarded to a visual artist to lecture in the Soviet Union, besides being awarded a New Jersey Fellowship for the Arts award and the Board of Trustees Research Fellowship Award from Rutgers University. Allen lectures widely and is in the collection of the Museum of Modern Art and the New York Public Library, New York; the Newark Public Library and The Noyes Museum, New Jersey; the Ministry of Culture in Sweden and Russia; and the Norton and Nancy Dodge Collection, among others.

PHYLLIS MCGIBBON is an Associate Professor of Printmaking at Wellesley College. She received her BFA and MFA from the University of Wisconsin-Madison, and typically works in a broad range of media, including prints, drawings, books, and site-based installations. McGibbon has been an artist-in-residence at print studios in Scotland, England, Belgium, Canada, and the United States, and her work is in many public collections, including the Getty Center and the Victoria and Albert Museum. She has received awards from the Elizabeth Greenshields Foundation, the WESTAF Regional NEA, Art Matters, Inc., and the National Endowment for the Arts.

Sounding (Witchcraft in Groton)
18" × 14" (46 cm × 36 cm)
Two-sided lithograph

INDEX AND DIRECTORY

Lari R. Gibbons **122**
1936 D St. Apt. 7
Lincoln, NE 68502

Ronald Glassman **12**
32 East Broadway
New York, NY 10002

Raymond Louis Gloeckler **142**
6801 Forest Glade Ct.
Middleton, WI 53562

Susan J. Goldman **38**
9404 Worth Ave.
Silver Spring, MD 20901

Sergio Gonzalez-Tornero **53**
30 Highridge Rd.
Mahopac, NY 10541

Beth Grabowski **133**
CB# 3405
Hanes Art Center
University of North
Carolina Chapel Hill
Chapel Hill, NC 27599-3405

Allen Grindle **101**
40 Broadway
Albany, NY 12202

Dawn Marie Guernsey **38**
7713 Underhill Dr.
St. Louis, MO 63133

Juli Haas **24, 26**
11 Trent Ct.
Traralgon, Victoria 3844
Australia

Roger Harris **41**
Springhill Cottage
Quarhouse, Brimscombe
Nr. Stroud, Gloucestershire
GL5 2RS
England

Florin Hategan **26**
28 Riverwood Parkway
#409
Etobicoke, ON M8Y 4E2
Canada

George Hawken **127**
62 Austin Terrace #1
Toronto, ON M5R 1Y6
Canada

Michael W. Hecht **108**
144 Moody St. 2nd floor
Waltham, MA 02154

Adriane Herman **131**
605 East Johnson #4
Madison, WI 53703

Nanci Hersh **115**
1 Park Gate Dr.
Edison, NJ 08820

Nona Hershey **12, 81**
32 Clifton St. #6
Somerville, MA 02144

J.C. Heywood **139**
Dept. of Art
Queens University
Kingston, ON K7L 3N6
Canada

Alison Hildreth **102**
50 Thornhurst Rd.
Falmouth, ME 04105

Yuji Hiratsuka **31**
1215 NW Kline Place
Corvallis, OR 97330

John Howard **83**
1, Spernen Wyn Road
Falmouth, Cornwall TR11
4EH
England

E.J. Howorth **128**
10 Roslyn Cres.
Winnipeg, MB. R3L OH7
Canada

Siegfried Otto
Hüttengrund **37**
Bachstrasse 24
Hermsoorf 09337
Germany

Kim Huynh **85**
#301 671 Woolwich St.
Guelph, Ontario N1H 3Y9
Canada

Magnus Irvin **80**
11 Lancaster Rd.
London N4 4PJ
England

Constance Jacobson **69**
30 Ipswich St. #102
Boston, MA 02215

Janis Jacobson **151**
140 Newark Ave.
Jersey City, NJ 07302

Sarojini Jha Johnson **120**
1205 Brentwood
Muncie, IN 47304

K.C. Joyce **43**
990 Madison
Eugene, OR 97402

Walter Jule **150**
Box 86, Site 1
R.R.2
Tofield, AB TOB-4J0
Canada

Louise Kames **106**
1550 Clarke Drive
Dubuque, IA 52001

Stanley Kaminski **15**
312 W. Alabama #8
Houston, TX 77006

Anne Karsten **134**
2314 N. Lawndale
Chicago, IL 60647

Nancy Kellar **120**
P.O. Box 340
Granville, OH 43023

David Kelso **13**
3246 Ettie St. #16
Oakland, CA 94608

Davida Kidd **119**
5511 Canada Way
Burnaby BC V5E 3N5
Canada

Wayne Kimball **25**
185 South 1300 E
Pleasant Grove, UT 84062-3025

William J. Kitchens **61**
Visual Arts Dept.
Loyola University
Box 906
6363 St. Charles Av.
New Orleans, LA 70118

Maria Korusiewicz **121**
Sandomierska 15/55
Katowice 40-216
Poland

Balazs Peter Kovacs **119**
Jozsef Nador Ter 9
Budapest 1051
Hungary

Michael Krueger **135**
2037 New Hampshire St.
Lawrence, KS 66046

Elena Kudinooa **107**
Moskovsky AV 96A, 258
Kharkov 310068
Ukraine

Julie Kvelgaard **140**
612 E. Samford Ave.
Auburn, AL 36830

Elspeth Lamb **35**
6 Drybrugh Gardens
Glasgow G20 8BT
Scotland

Martin Langford **89**
13 Cannon Lane
Pinner, Middlesex HA5
1HH
England

Kate Leavitt **44**
116 Old Orchard Lane
Malta, NY 12020

Ingrid Ledent **153**
Leopoldslei 71
Brasschaat B-2930
Belgium

Martin Levine **144**
25 Main St.
Setauket, NY 11733

Maria Lindstrom **130**
Bondesons G. 8
Stockholm 11252
Sweden

Jean Lodge **133**
52 Granville Court
Cheney Lane
Headington, Oxford OX3
OHS
England

Pam Longobardi **76**
2524 Jefferson Avenue
Knoxville, TN 37914

Mil Lubroth **17**
Edificio Torres Blancas
Avda. de America 37
Madrid 28002
Spain

Linda Lyke **68**
569 Lotus St. La.
Los Angeles, CA 90065

Beauvais Lyons **28**
1715 Volunteer Blvd.,
UTK
Knoxville, TN 37996-2410

Thomas H. Majeski **51**
1315 Silver St.
Ashland, NE 68003-1843

Pavel Makov **105**
Moskovsky Prospect 90-34
Kharkov 310005
Ukraine

Peter Marcus **22**
6376 Alamo
St. Louis, MO 63105

Michelle Martin **96**
P.O. Box 6046
Kingwood, TX 77325

Ron McBurnie **56**
P.O. Box 5038
Townsville 4810
Australia

Rose K. McCaughey **92**
30 Charter Oaks Dr.
Pittsford, NY 14534

Suzanne McClelland **77**
Tamarind Institute
108 Cornell Drive SE
Albuquerque, NM 87106

Robin McCloskey **92, 95**
2901 Middlefield Rd. #4
Palo Alto, CA 94306

Phyllis McGibbon **157**
Wellesley College
Jewett Arts Center
106 Central Street
Wellesley, MA 02181-8257

Jeane K. McGrail **104**
1040 W. Hurn #22W5
Chicago, IL 60622

Chung Mee-Young **113**
74-6 Banpo 4 Dong
Seocho-Gu, Seoul 137-044
Korea

Bert Menco **27**
840 Michigan Ave. #9
Evanston, IL 60202-2588

Hugh J. Merrill **79**
2926 Charlotte St.
Kansas City, MO

Árpád Miklós **82**
Liszt F.
Hungary

Nestor Millan **100**
Cond. University Court,
Apt. 5-B
872 Esteban Gonzalez St.
Rio Piedras, PR 00925

Scott Miller **53**
UA Dept. of Art
Box 870270
Tuscaloosa, AL 34587-0270

Barbara Milman **77**
2814 Belhaven Pl.
Davis, CA 95616

Natalia Mironenko **102**
Kultury Street 9, Apt. 41
Kharkov 310058
Ukraine

Wayne Miyamoto **7, 18**
359 Hoaka Rd.
Hilo, HI 96720

David Mohallatee **62**
5105 Argus Ave. NW
Albuquerque, NM 87120

Emmanuel C. Montoya **94**
2016 Ninth St.
Berkeley, CA 94710

Laura E. Moriarty **137**
84 Dellay Ave.
Kingston, NY 12401

David Morrison **126**
6819 Sunrise Dr.
Plainfield, IN 46168

Frances Myers **19**
8788 County Highway A
Hollandale, WI 53544

Tom Nakashima **145**
436 M St., NW #9
Washington, DC 20001

Marte Newcombe **106**
1821 MacArthur Dr.
McLean, VA 22101

Geert Opsomer **46**
Grasareef 39
8790 Waregem
Belgium

Judith Palmer **29**
2040 Arroyo Dr.
Riverside, CA 92506

Pasternak **72**
1141 Chaussée de
Waterloo
1180 Bruxelles
Belgium

Jim Pattison **50**
37 Beechwood Dr.
Broomhill, Glasgow G11
7ET
Scotland

Brian Paulsen **18**
320 N. 16th St.
Grand Forks, ND 58203-3059

Elizabeth J. Peak **111**
2807 27th St. N
Arlington, VA 22207

Glen Rogers Perrotto **8, 60**
18595 Ralya Ct.
Cupertino, CA 95014

Melvyn L. Petterson **67**
92 Grove Park
Camberwell, London SE5 8LE
England

Carole Pierce **85**
P.O. Box 1032
Ross, CA 94957

Margaret H. Prentice **34, 57**
2480 Malabar Dr.
Eugene, OR 97403

Joe Price **97**
P.O. Box 3305
Sonora, CA 95370-3305

Erena Rae **54**
1007 Thistlewood Dr.
Norman, OK 73072-3941

Kathryn J. Reeves **74**
2217 Miami Trail
W. Lafayette, IN 47906

Marina Richter **138**
Tuneláru 333
Praha 5 - Zbraslav 15600
Czech Republic

Veerle Rooms **20, 36**
Cogels Osylei 7
2600 Berchem
Belgium

Sheila Ross **70**
P.O. Box 10846
Bainbridge Island, WA 98110

Laura Ruby **39, 40**
509 University Avenue #902
Honolulu, HI 96826

Stephanie Russ **122**
1070 de la Montagne
Montreal, Quebec H3G-147
Canada

Jeanine Coupe Ryding **100**
928 Wesley Ave.
Evanston, IL 60202

Rosanna Saccoccio **110**
440 NE 3rd Ave.
Fort Lauderdale, FL 33301

Orlando Salgado **112**
P.O. Box 9022577
San Juan, PR 00902-2577

Boyd Saunders **9**
533 Mallard Dr.
Chapin, SC 29036

Teresa T. Schmidt **123, 137**
1915 Pierre St.
Manhattan, KS 66502

E. Jessie Shefrin **97**
190 Mullen Rd.
Alfred Station, NY 14803

Elaine Shemilt **32**
12 Douglas TCE
Broughty Ferry
Dundee DD5 1EA
Scotland

Yoshiko Shimano **45**
2221 Parker St., Apt. C
Berkeley, CA 94704

Guntars Sietins **140**
A.K. 117
Riga LV 1002
Latvia

Stephen R. Simons **68**
2942 Skimmerhorn St.
Fort Collins, CO 80526

Jeffrey L. Sippel **34**
425 Carlisle NE
Albuquerque, NM 87106

Mark D. Sisson **21**
127 Melrose Drive
Stillwater, OK 74074

Ralph D. Slatton **148**
314 N. Willow Ave.
Erwin, TN 37650

Laurie Sloan **146**
491 N. Eagleville Rd.
Storrs, CT 06268

Tanja Softic **65**
309 E. Yale St.
Orlando, FL 32804

Michael Southern **93**
7425 SW 27th Ave.
Portland, OR 97219

Herlinde Spahr **58**
88 Evergreen Dr.
Orinda, CO 94563

Scott Stephens **87**
815 Vine St.
Montevallo, AL 35115

Paul L. Stewart **98**
2281 Ayrshire
Ann Arbor, MI 48105

Emma Stibbon **81**
30 Islington Rd.
Southville, Bristol BS3 1QB
England

Juergen Strunck **10**
Box 92685
Southlake, TX 76092

Chippa Sudhakar **48**
H. No.4-87, Vikasnagar
Dilshuknagar, Hyderabad
Andhra Pradesh 500 036
India

Matthew Sugarman **66**
519 1st St.
Cedar Falls, IA 50613

Mary Margaret Sweeney **73**
39 Government St.
Kittery, ME 03904-1652

Lisa Sweet **111**
1049 E. Gorham #2
Madison, WI 53703

Sandy Sykes **55**
12 Kirkley Rd.
London SW19 3AY
England

Jan Szmatloch **10, 58**
Dluga Str. 7a/1 41-506
Chorzów
Poland

Otis Tamasauskas **62**
Dept. of Art
Ontario Hall
Queen's University
Kingston, ON K7C 3NG
Canada

Sergei Tsvetkov **8, 153**
3979 York Rd.
Furlong, PA 18925

Sarah Van Niekerk **78**
Priding House
Saul, Gloucestershire GL2 7LG
England

Carmela Venti **109**
78 Great Neck Rd.
Waterford, CT 06385

Ariel Vik **87**
729 Gratz St.
Knoxville, TN 37917

George Walker **50**
73 Berkshire Ave.
Toronto, ON M4M 2Z6
Canada

Naohiko Watanabe **14**
40 Parade Mansions
Watford Way
London NW4 3JJ
England

Arthur Watson **25**
Duncan of Jordanstone College
University of Dundee
13 Perth Rd.
Dundee DD1 4HT
Scotland

Carol Wax **86**
7 Second St.
Brooklyn, NY 11231

Ruth Weisberg **6**
University of Southern California
School of Fine Arts
Los Angeles, CA 90089-0292

Frans Wesselman **117**
119 Watling St.
Church Stretton SY6 7BJ
England

Catherine Wild **142**
40 Arlington Ave.
Toronto, ON M6G 3K8
Canada

Sherrie Wolf **17**
2334 NW Northrup St.
Portland, OR 97210

Judy Youngblood **125**
10622 Royal Springs Dr.
Dallas, TX 75229

Lawrence Yun **104**
20848 New Hampshire Ave.
Torrance, CA 90502

Barbara Zeigler and Joan Smith **126**
Dept. of Fine Arts
University of British Columbia
Vancouver, BC V6T 1Z2
Canada

Nele Zirníte **131**
Vangazu 12-41
Riga LV 102U
Latvia